THE UNOFFICIAL

SQUID GAME

COLORING BOOK

THE UNOFFICIAL

SQUID GAME

COLORING BOOK

Illustrated by
Rayana Ysabel De Pano Soller

EPIC INK

"DOING SOMETHING
IS ALWAYS MORE
FUN THAN
JUST WATCHING."

– OH IL-NAM

Ah, childhood. A time of no worries and the freedom to play fun games like hopscotch, marbles, Tug of War, and Red Light, Green Light with our friends. Who knew being good at those games from our youth could someday be worth $45.6 billion Won ($38,122,800 USD)?

The hit Netflix show *Squid Game* turns lighthearted games for children into not-so-fun challenges, but surprisingly, leaves out one of the greatest pastimes ever—coloring! Enter *The Unofficial Squid Game Coloring Book*, a templated journey depicting scenes and motifs from the show in creative and unique ways. All it needs is a little color, and that's where you come in.

Colors communicate. How we see color and how colors contrast are all part of creating a message. We bring ideas to life and use the reflections we see to shape what we want others to focus on and understand. And, just like in *Squid Game*, every color has a hidden message. In Red Light, Green Light, we hear Sang-Woo tell Gi-Hun, "You won't be caught if you hide behind someone." The scene is trying to communicate a deeper message, and similarly, you can use your coloring skills to express your thoughts and feelings, whatever they may be.

LET ME REPEAT THE INSTRUCTIONS . . .

Unlock your creative freedom and channel your inner artist to fill in these templates of the *Squid Game* characters and games you know and love. Find your favorite character's number and replicate the colors of the jumpsuits, or use your imagination to change it up—how would you style the *Squid Game* cast? Would you make the courses of the games different?

Check your knowledge of the series with hidden items, or perhaps add some new components of your own. Did the show leave out vital elements that you would have included if you were the creator of the games? Challenge yourself to recreate the iconic scenes, take it back to the basics of coloring, or let your imagination run wild! Maybe even think about this coloring book as one of the obstacles you need to overcome in *Squid Game*.

Just like coloring, all the games in the series are based on childhood classics, so take the opportunity to brush up on your creativity skills . . . you know, just in case you find yourself kidnapped into a life-or-death contest for billions of dollars. Play your own games or challenge your friends to coloring contests while a familiar waltz plays on repeat. Whatever you do, just make sure to play safely and always fair!

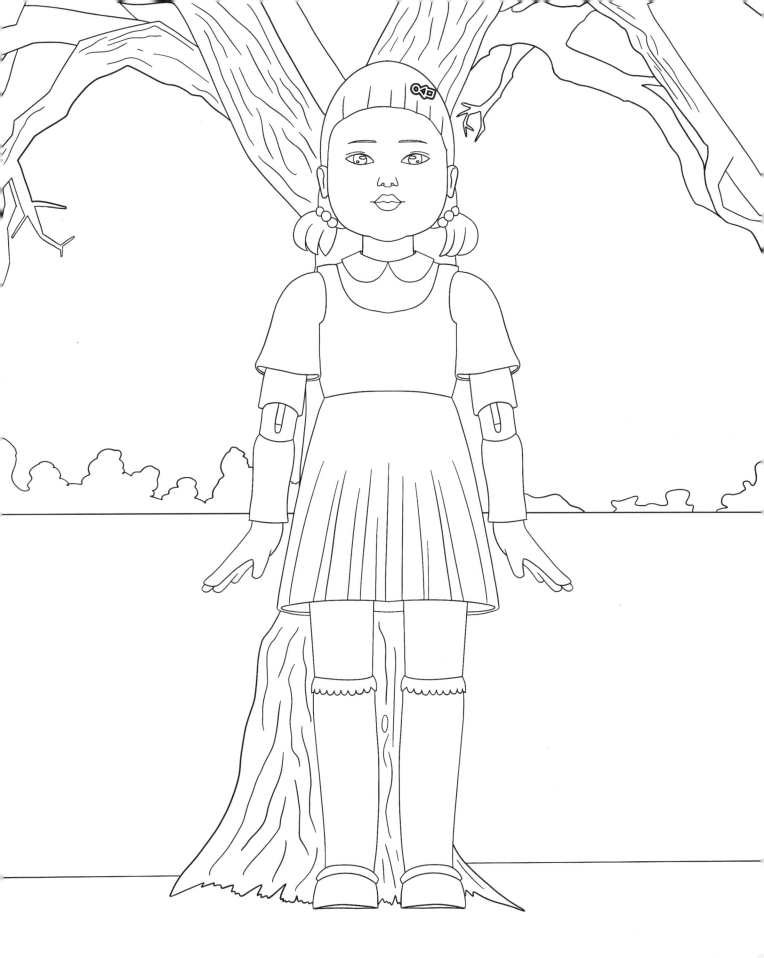

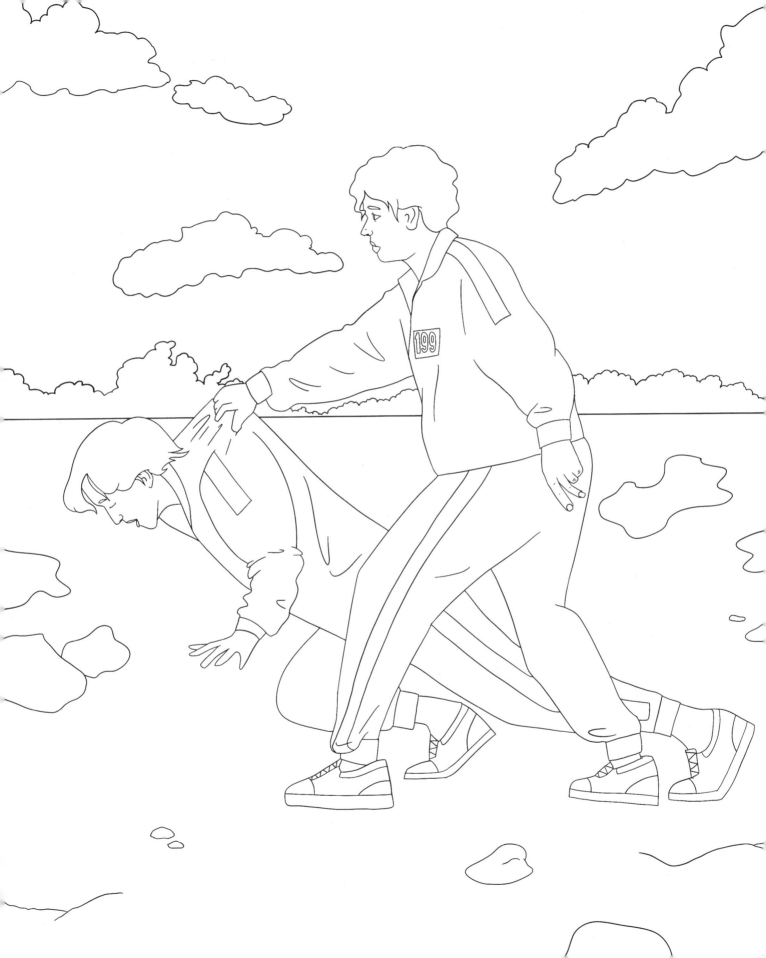

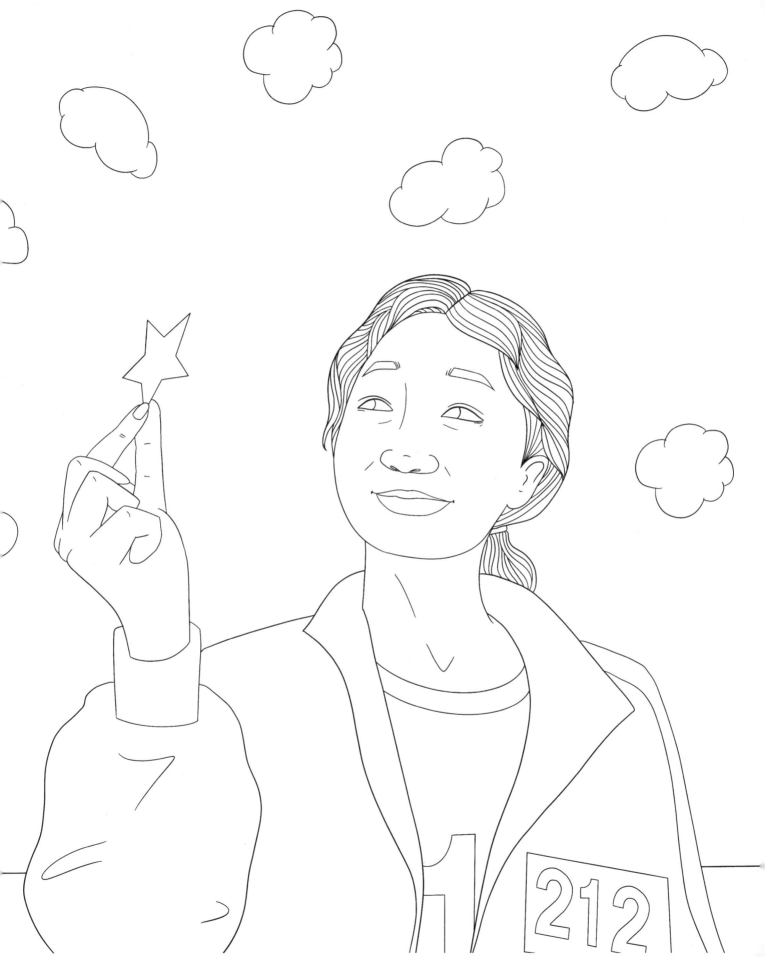

In here, I stand a *chance* at least. *Out there?* I got NOTHING out there.

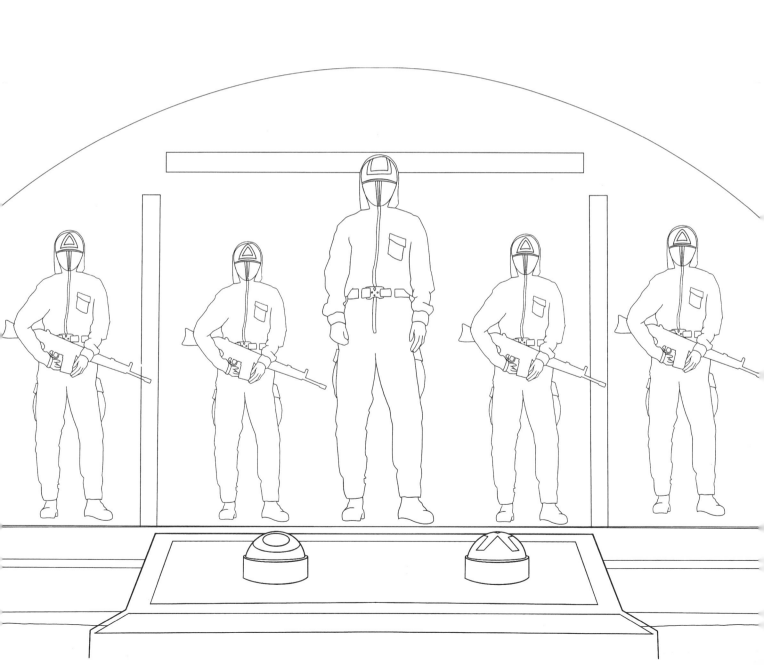

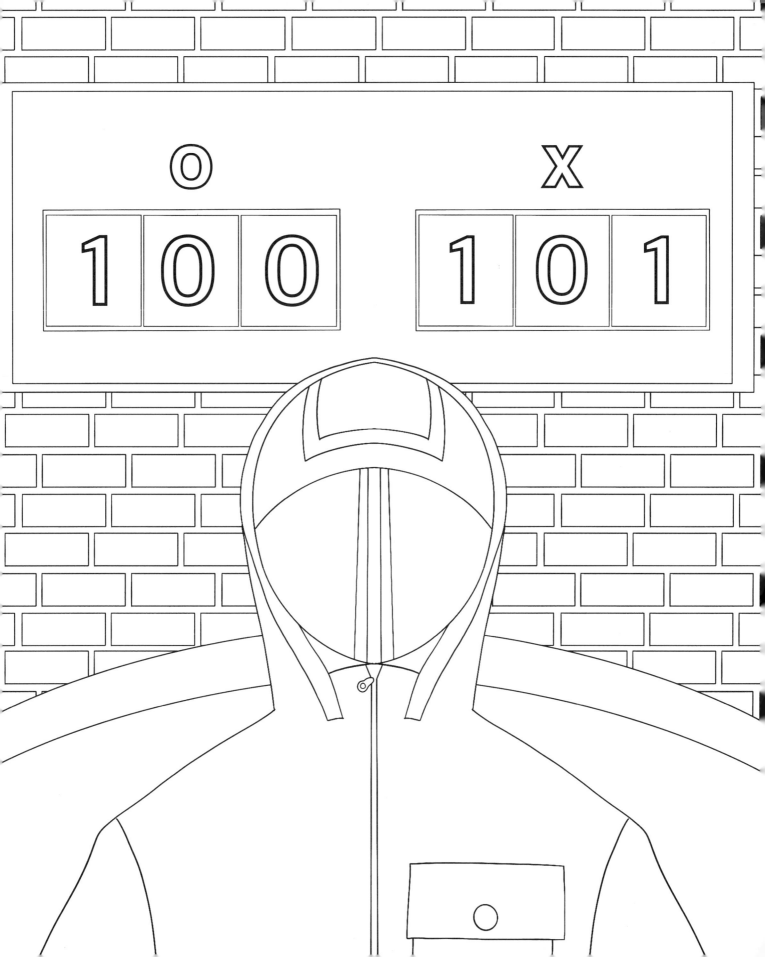

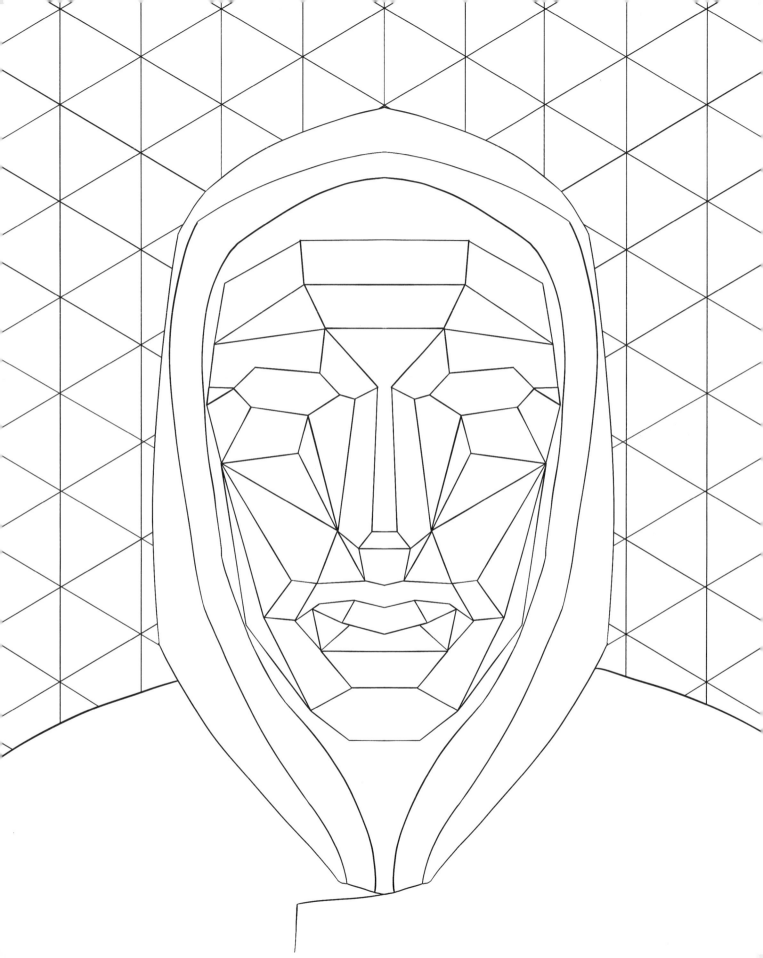

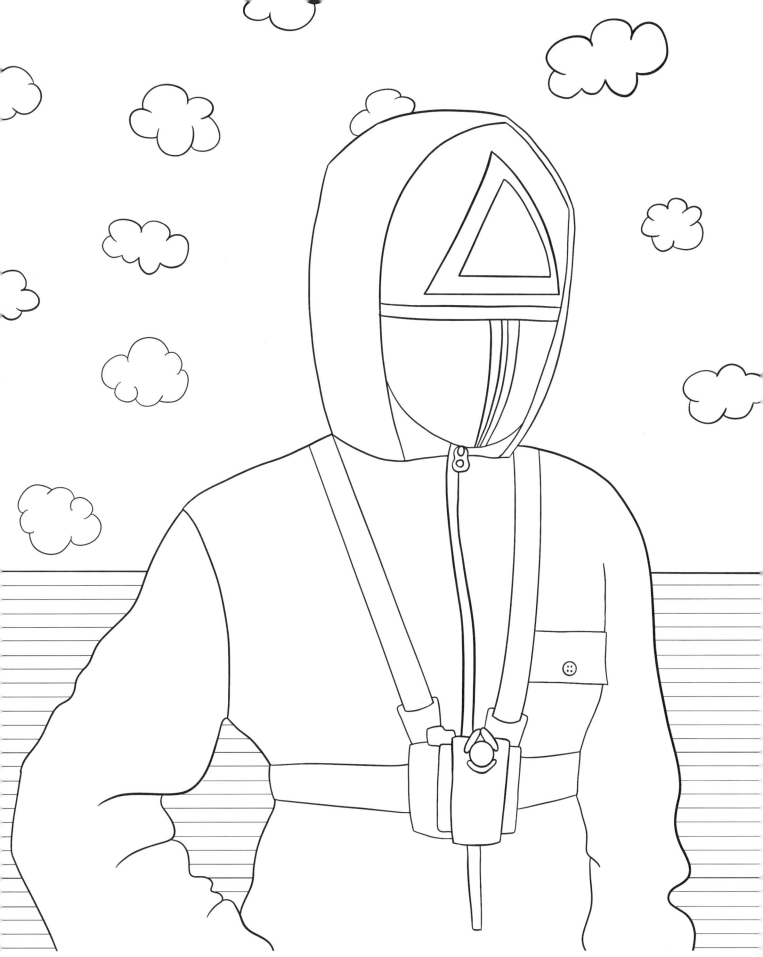

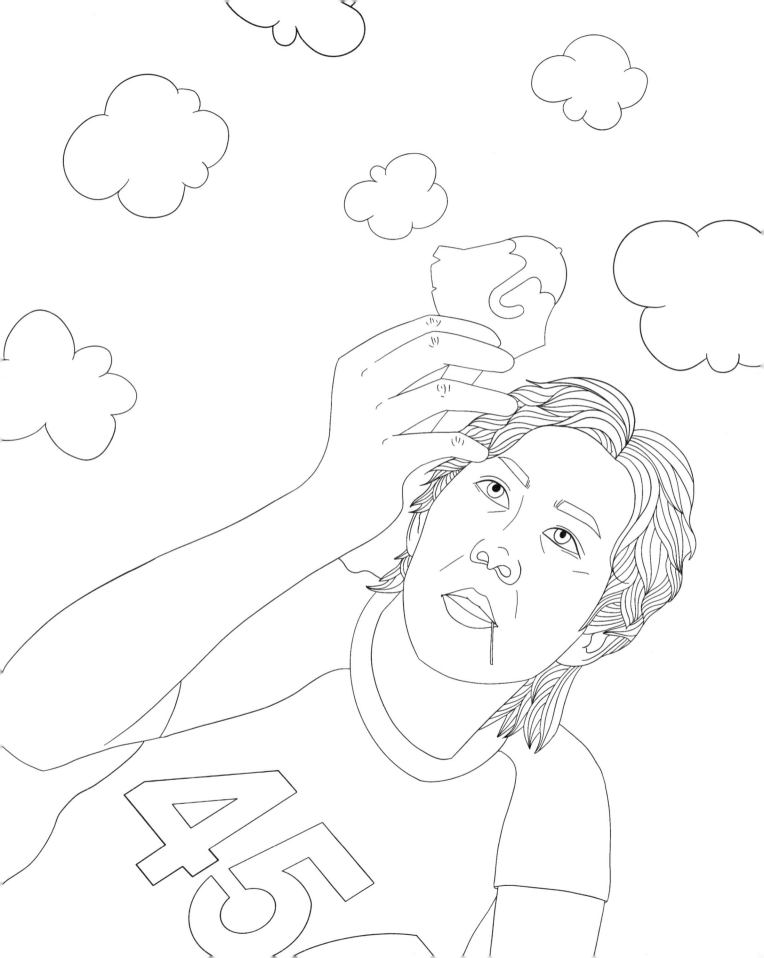

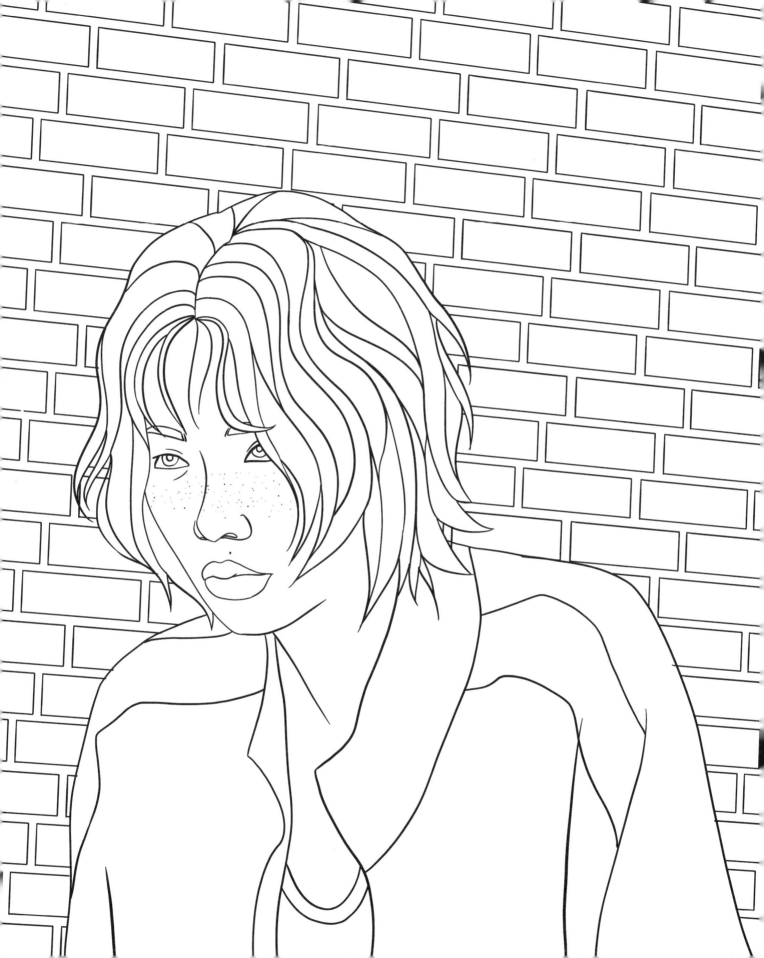

We've already come *too* FAR to END this now.

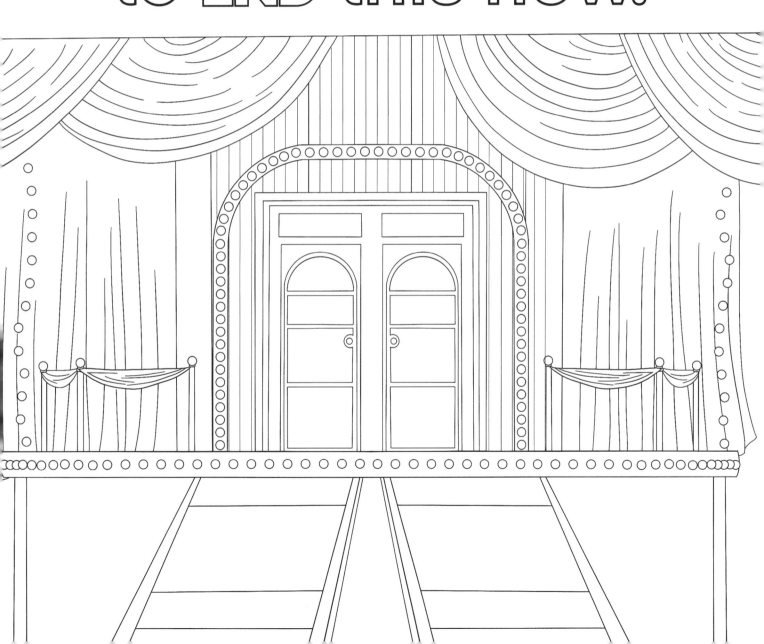

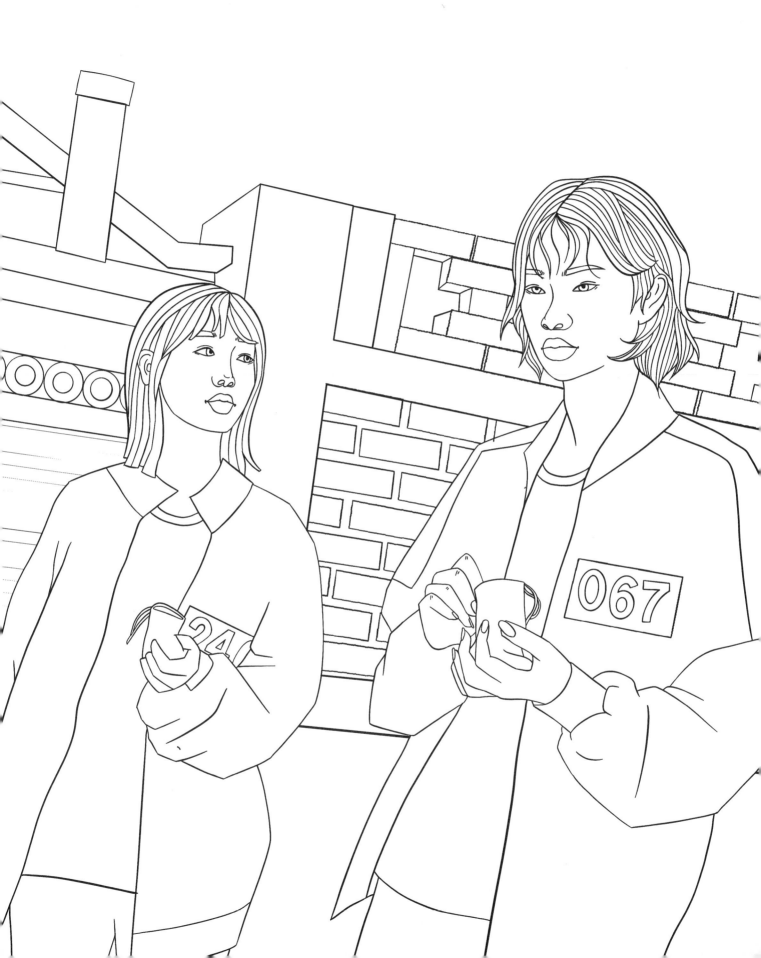

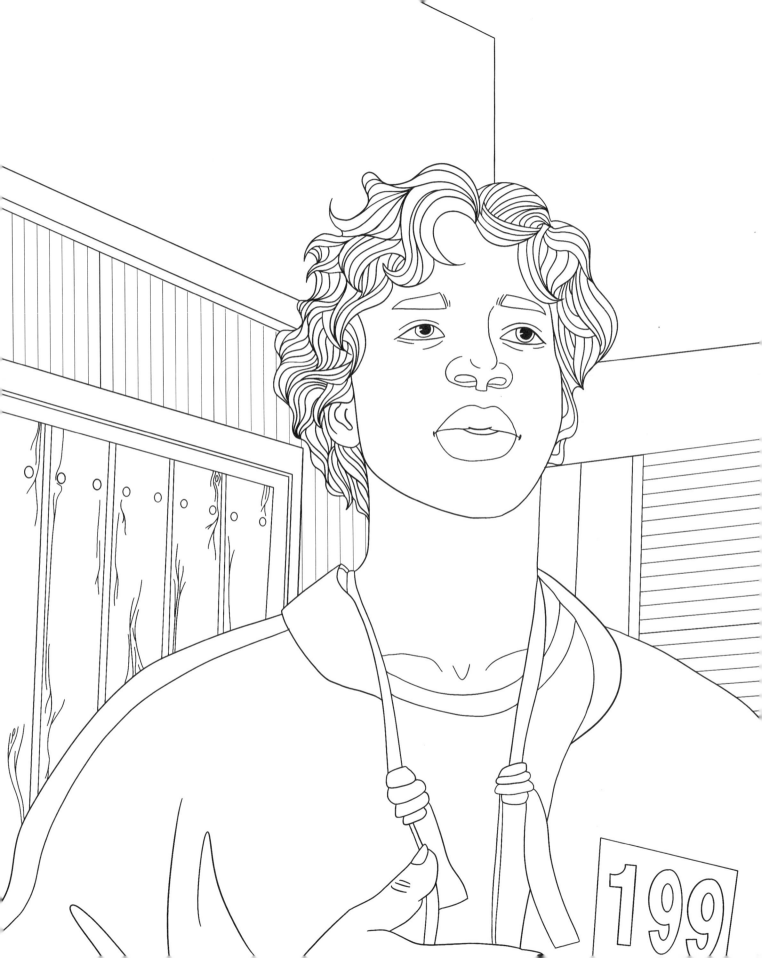

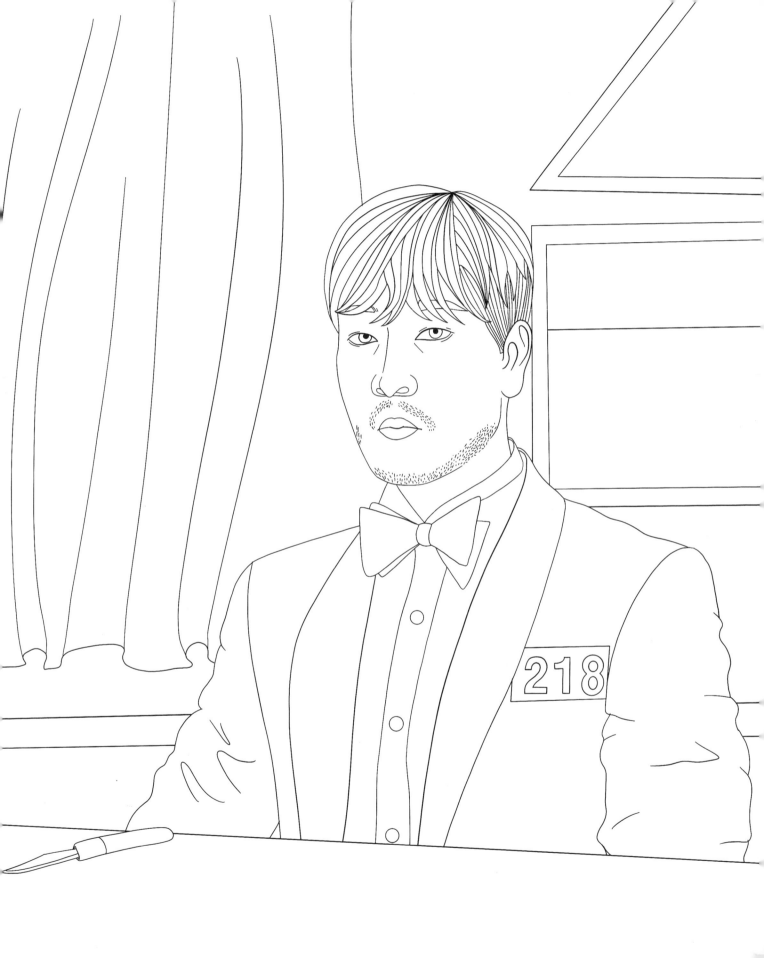

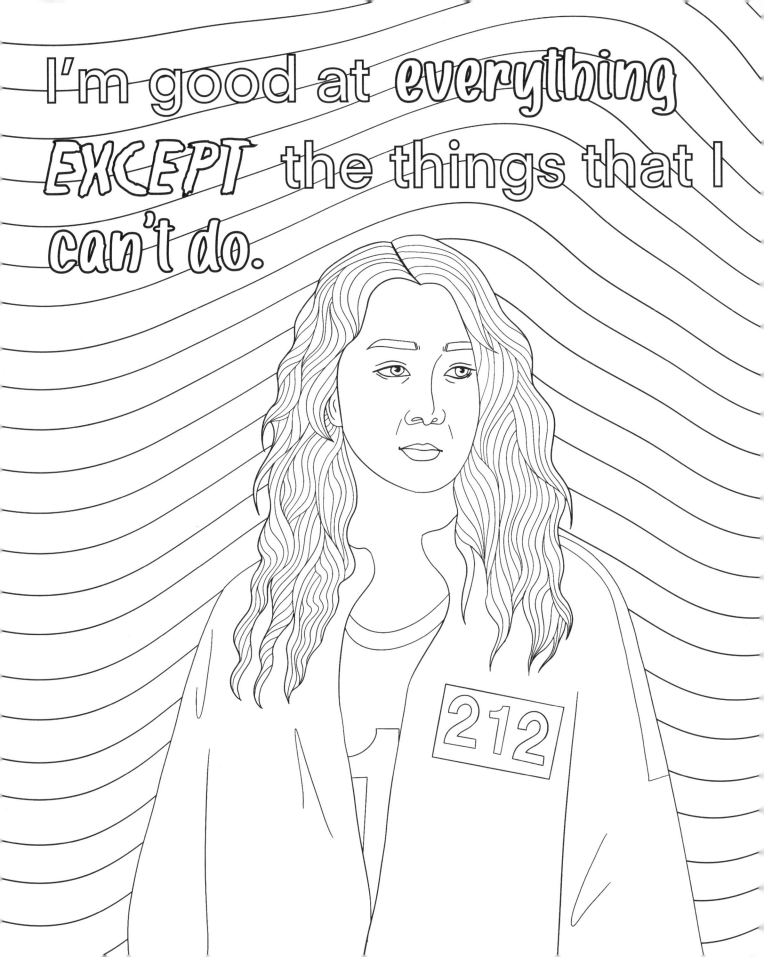

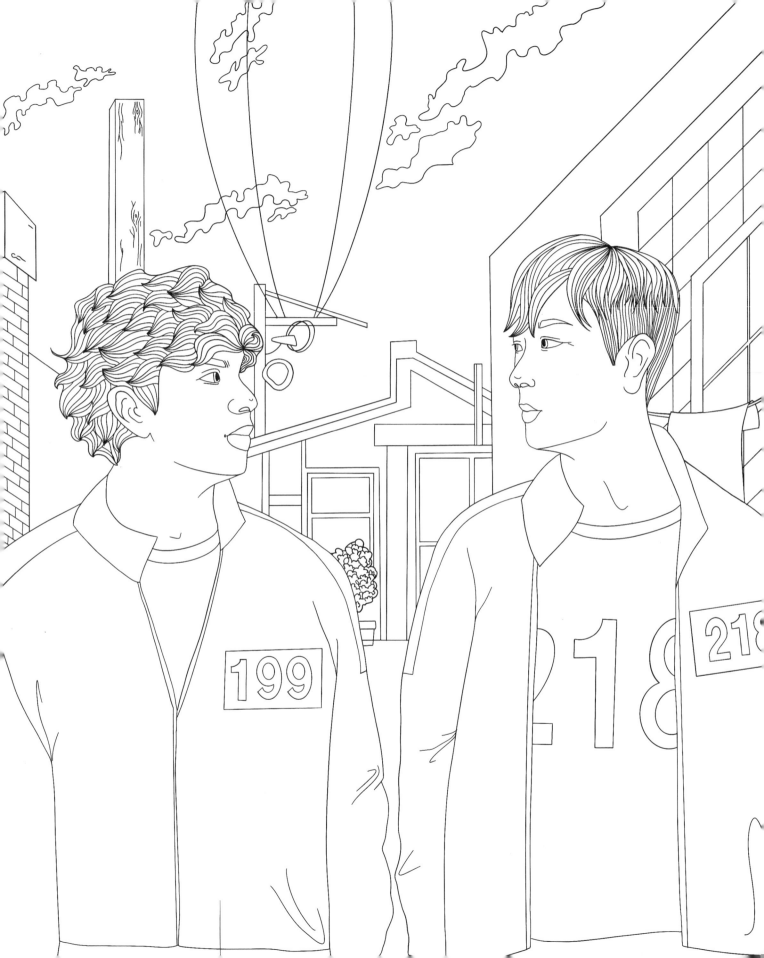

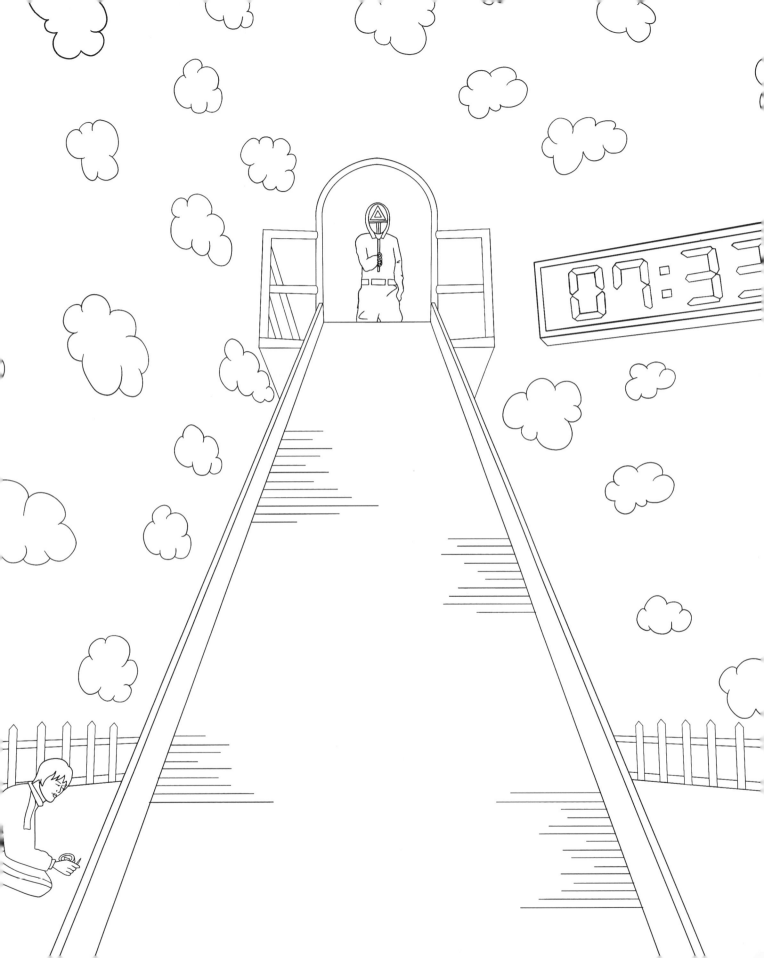

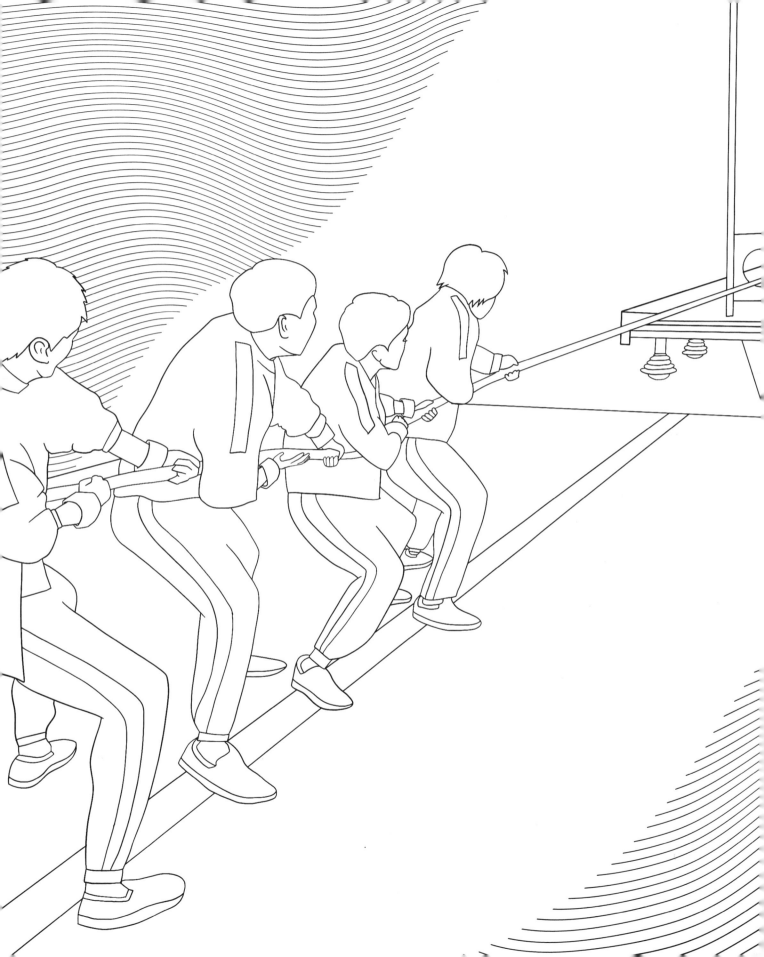

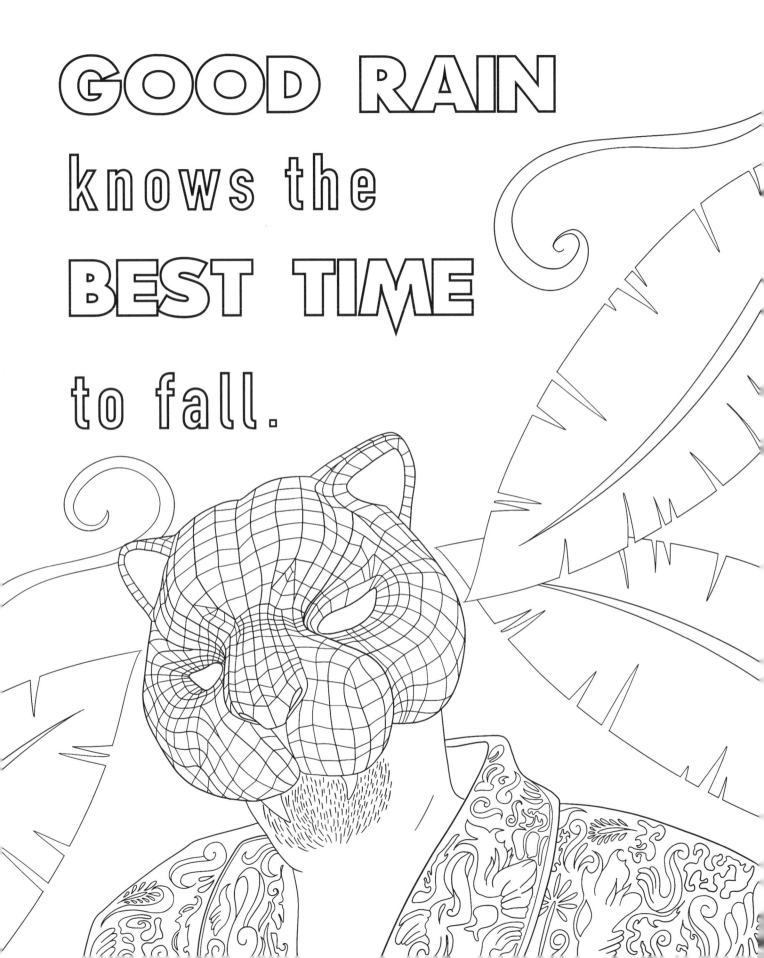

GOOD RAIN
knows the
BEST TIME
to fall.

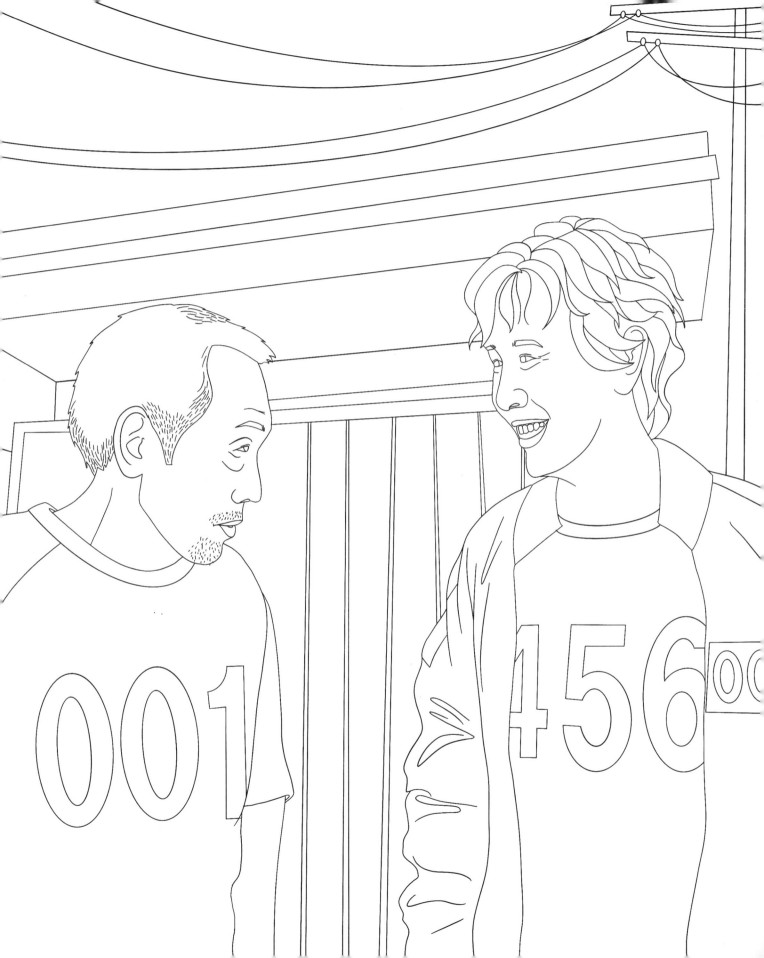

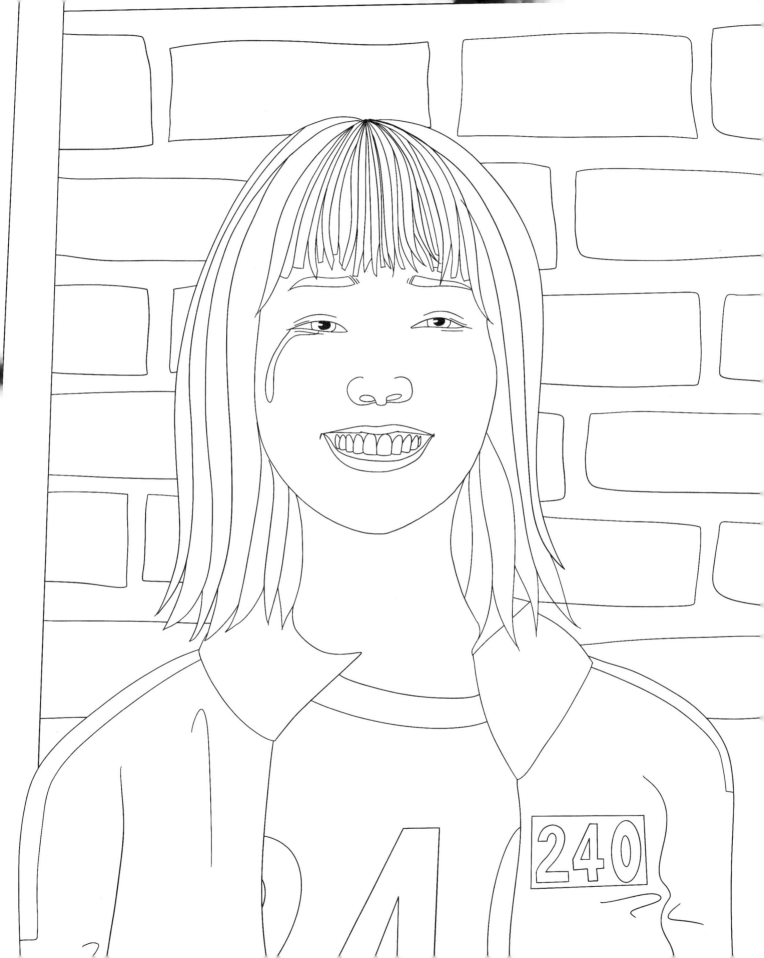

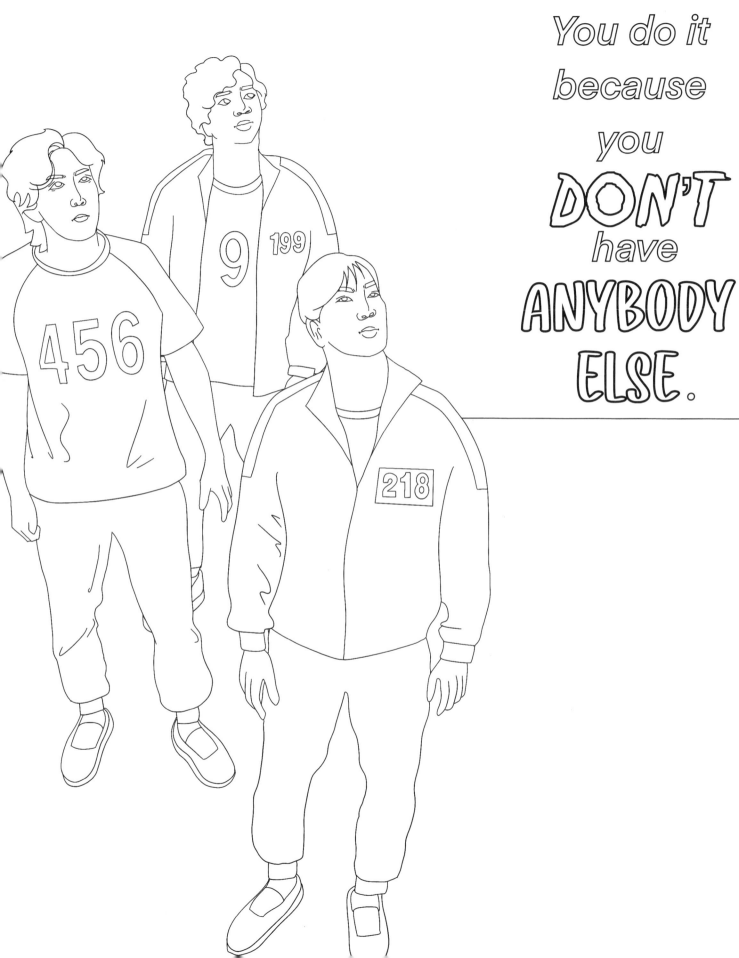

You do it because you **DON'T** have **ANYBODY ELSE.**

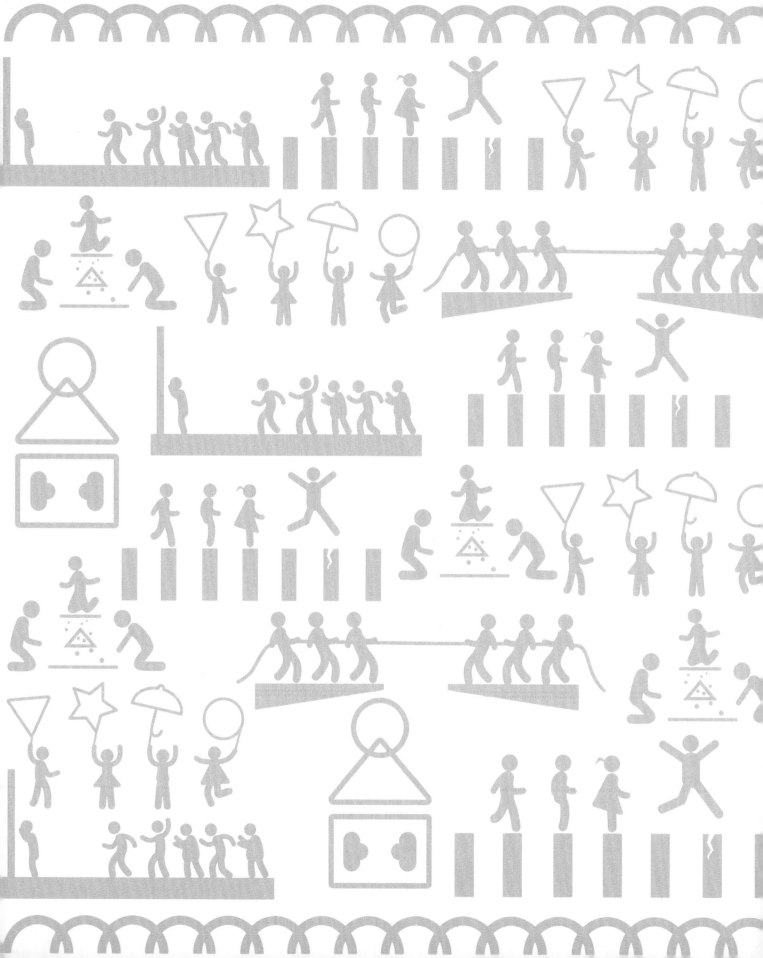

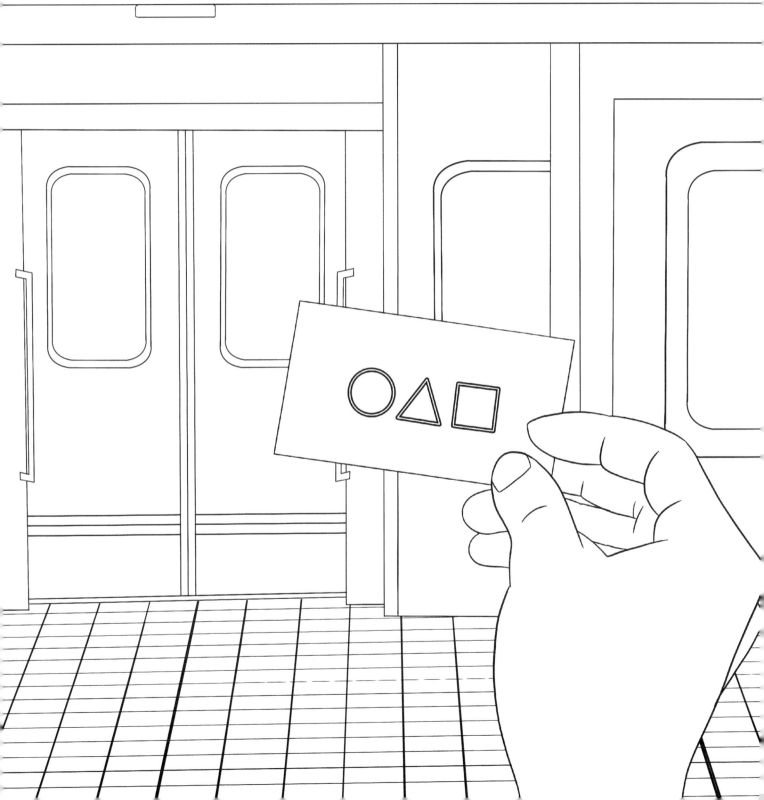

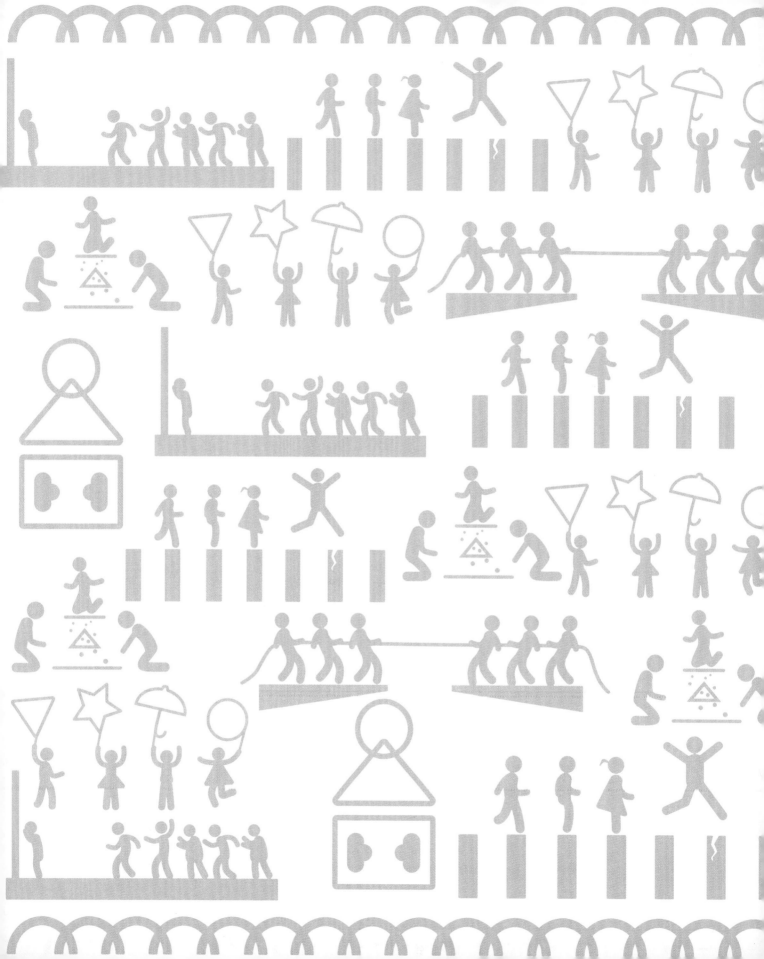

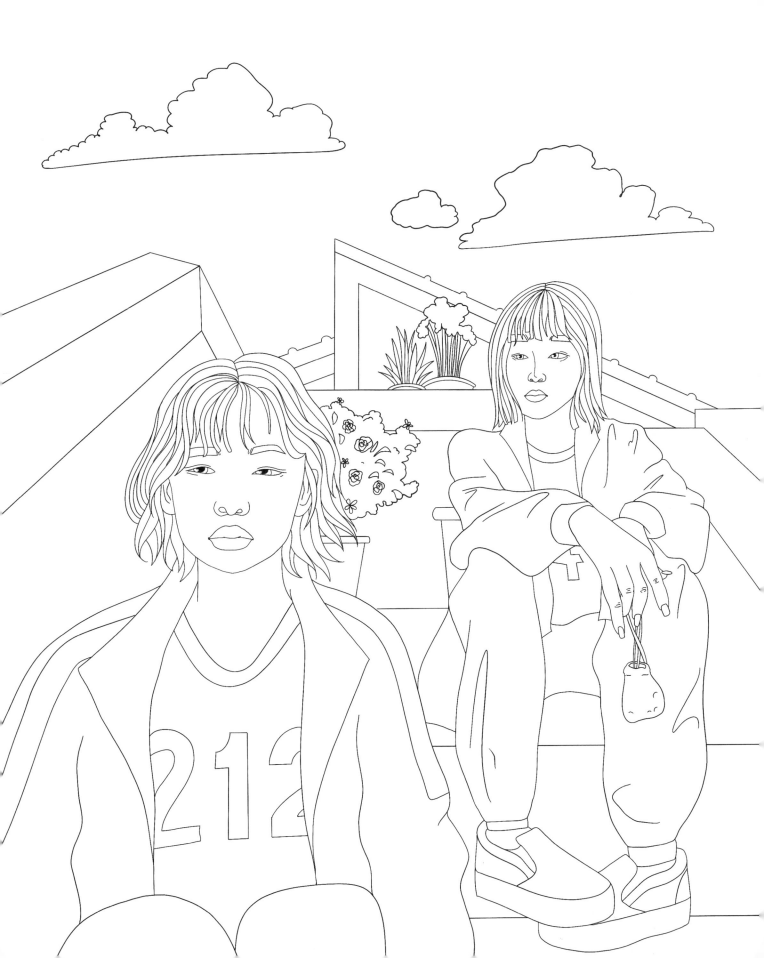

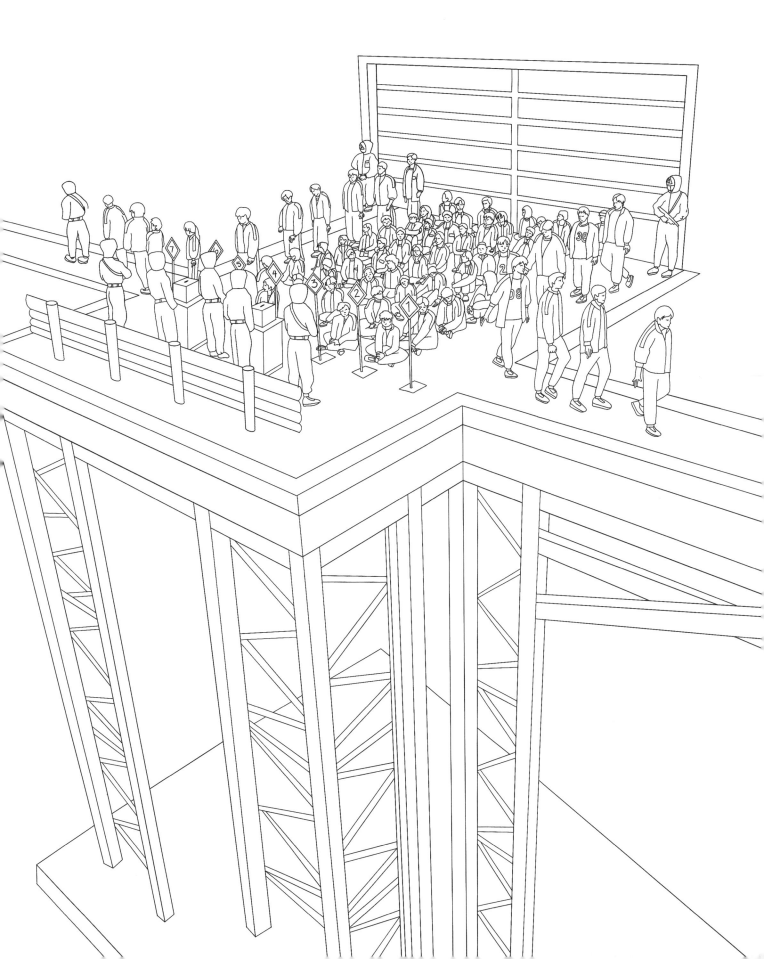

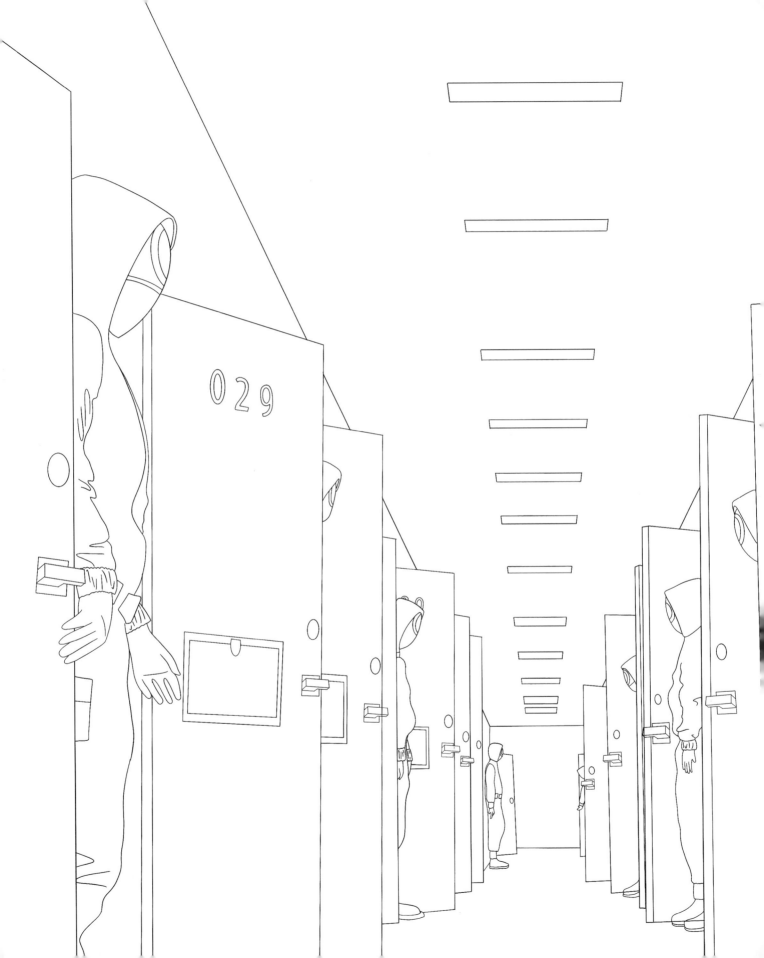

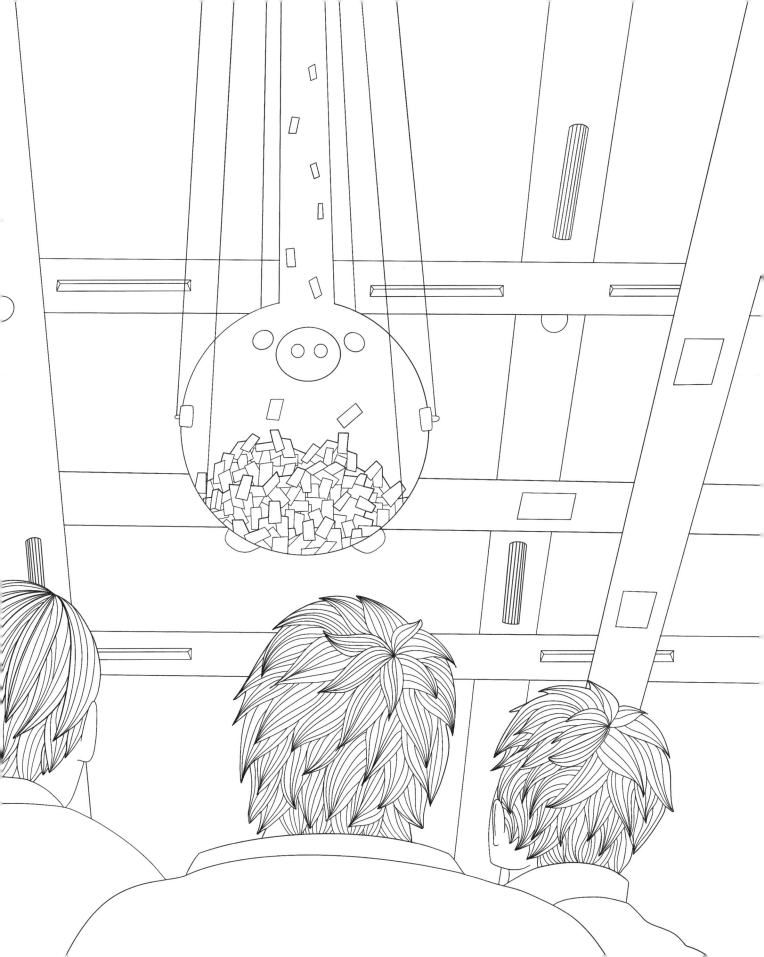

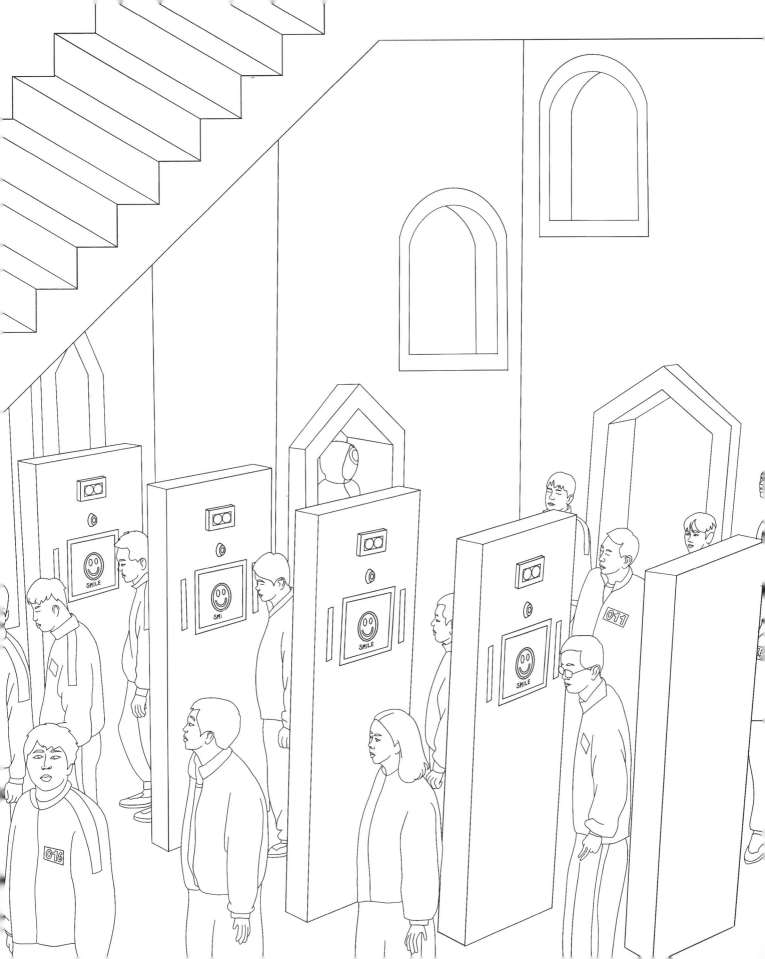

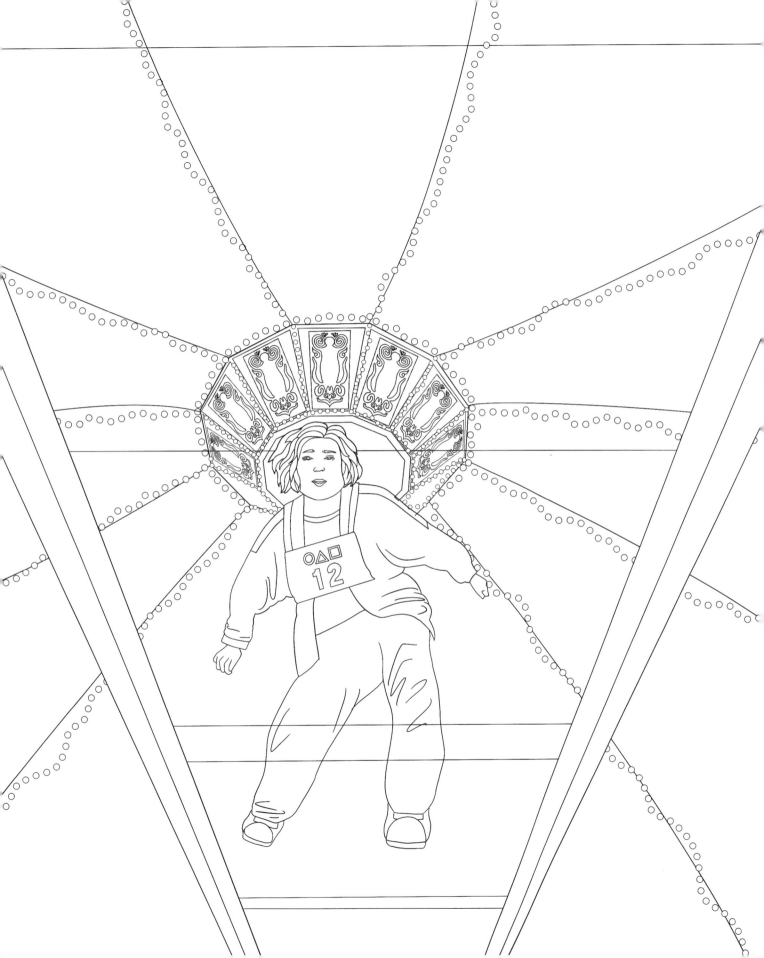

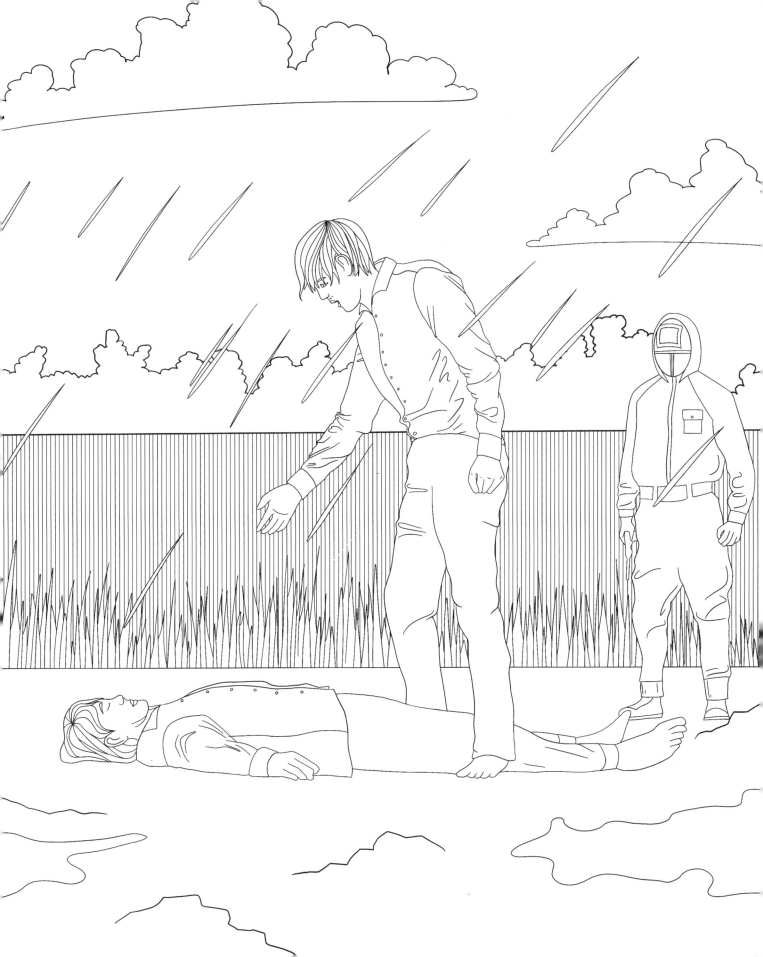

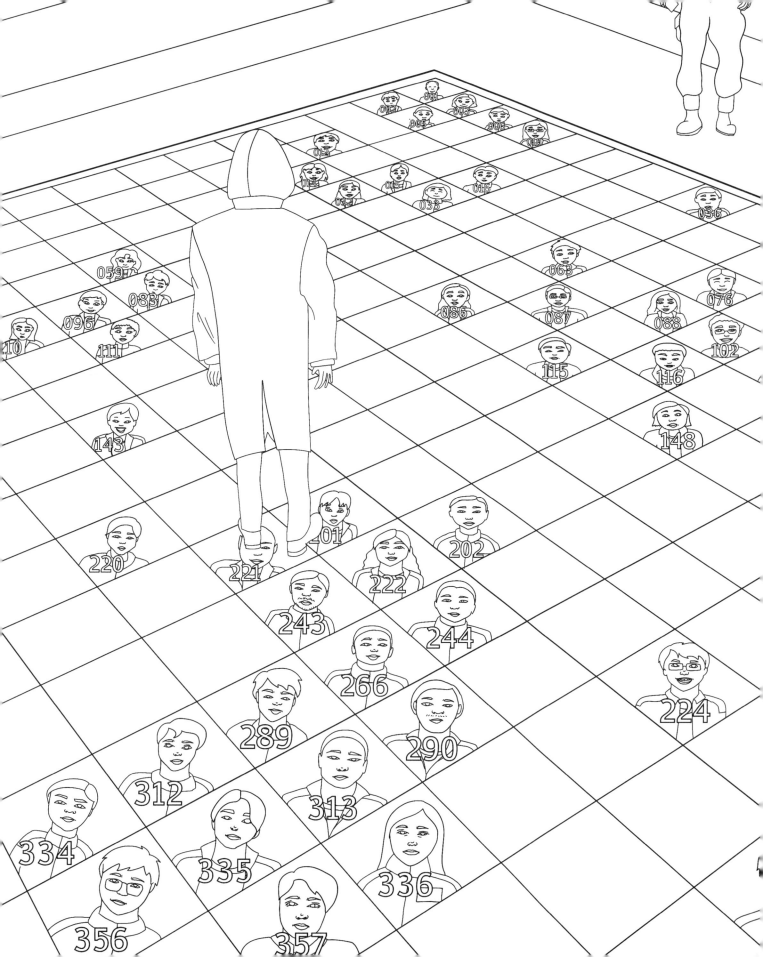

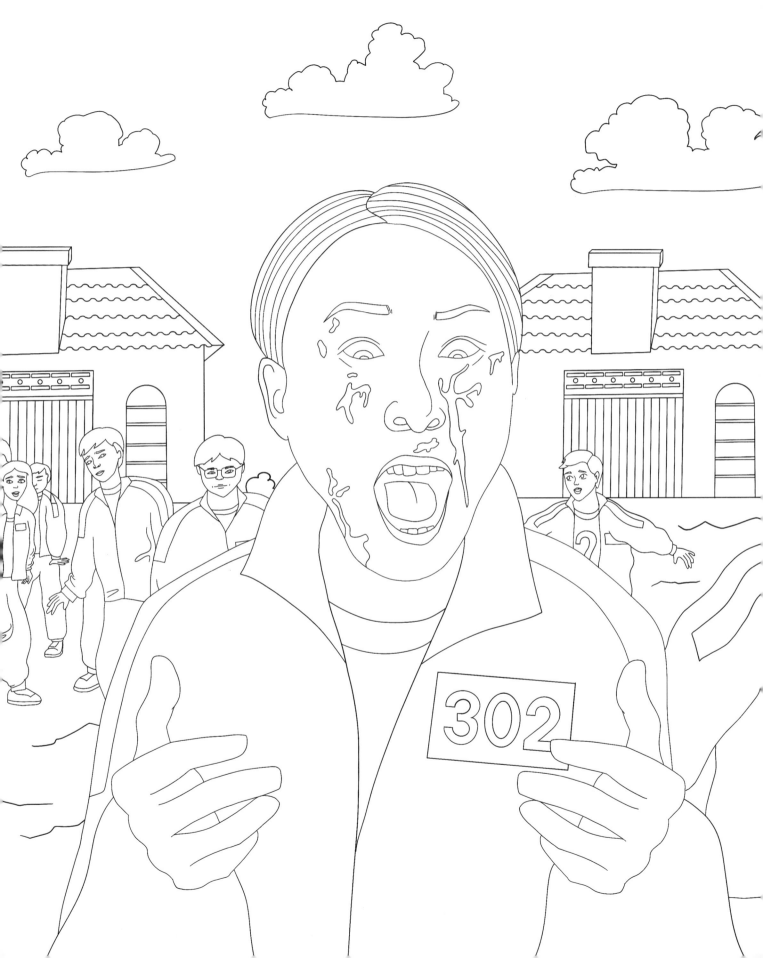

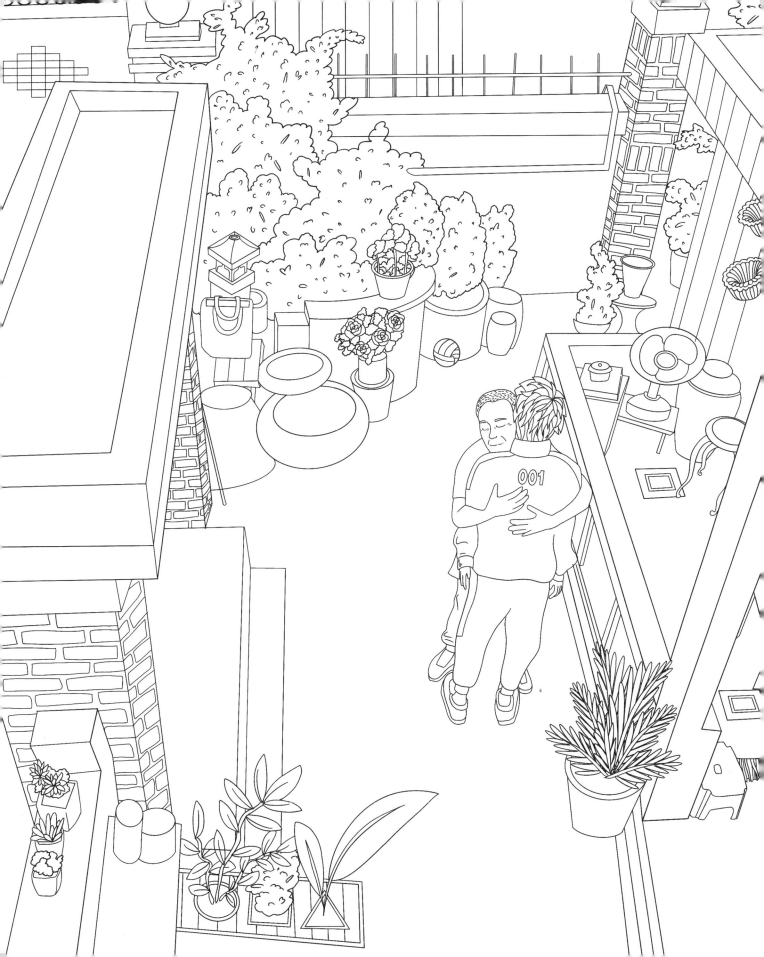

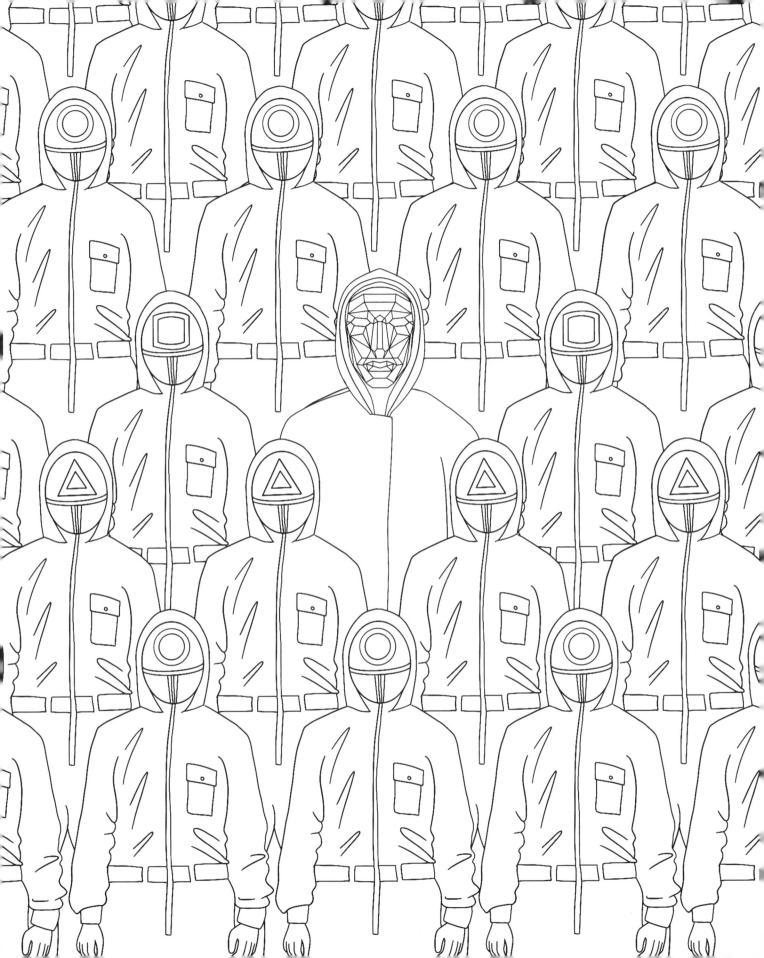

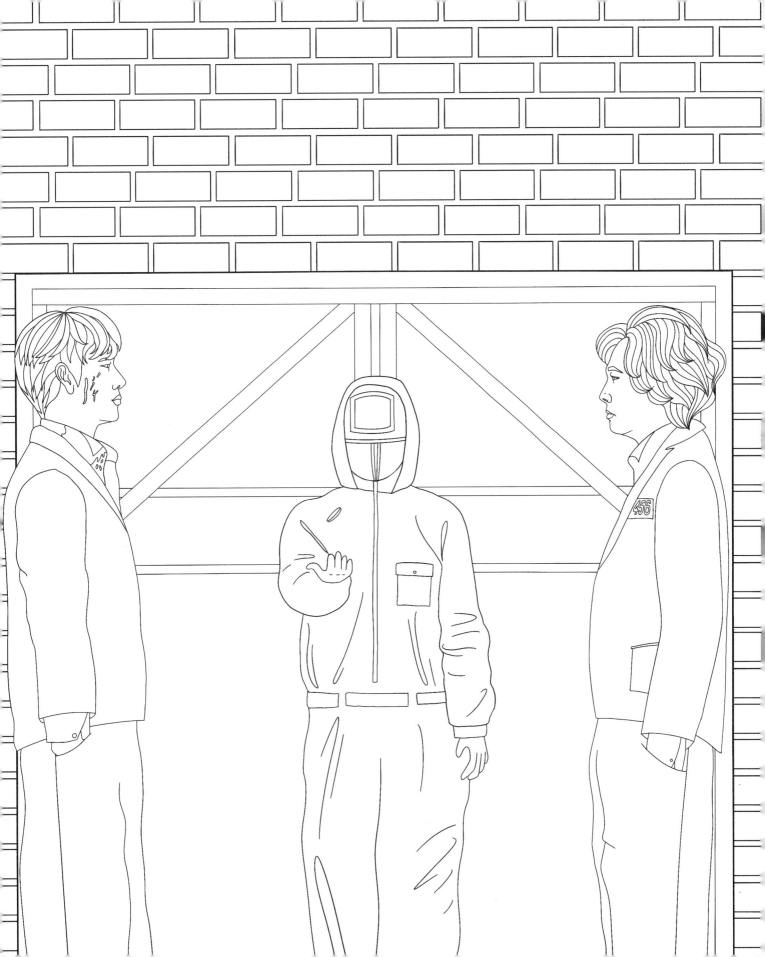

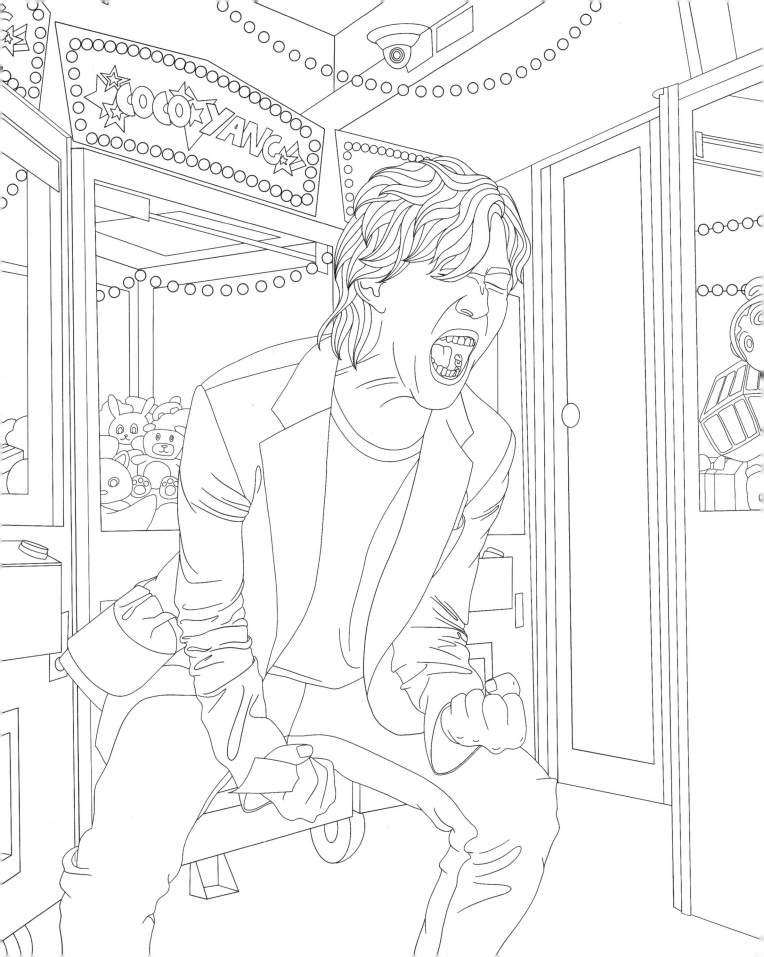

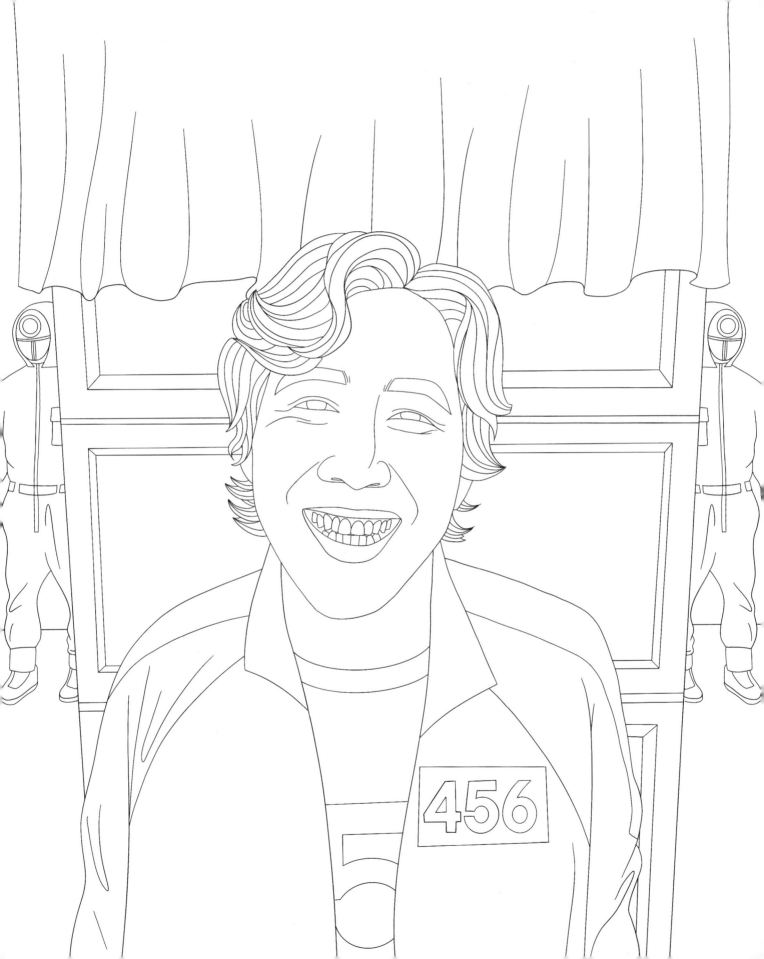

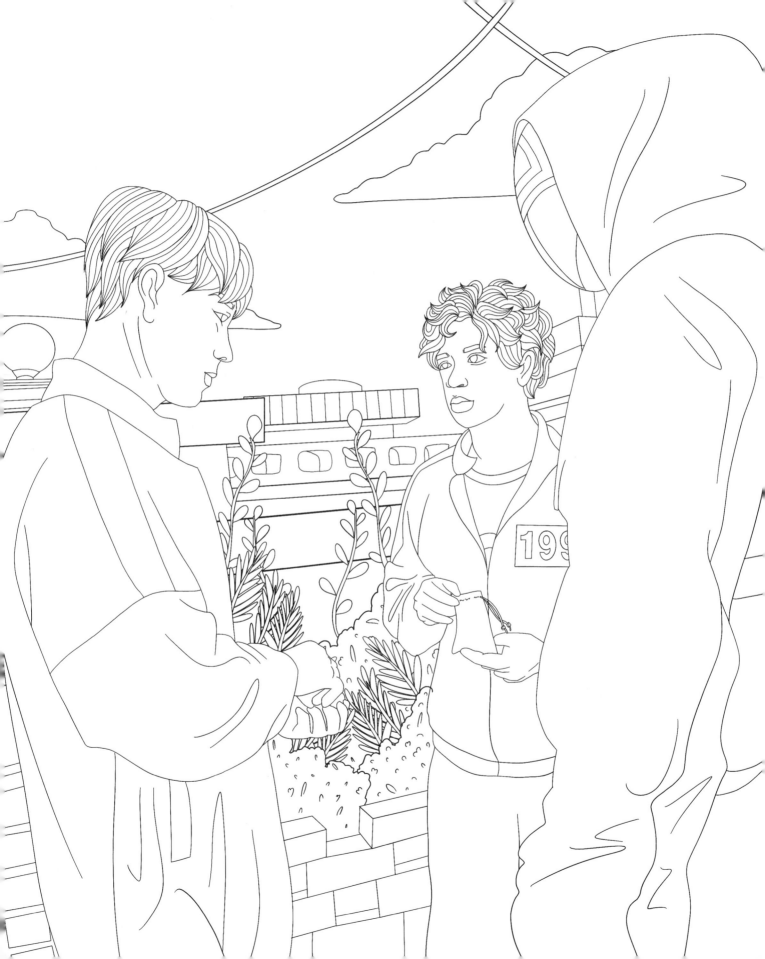

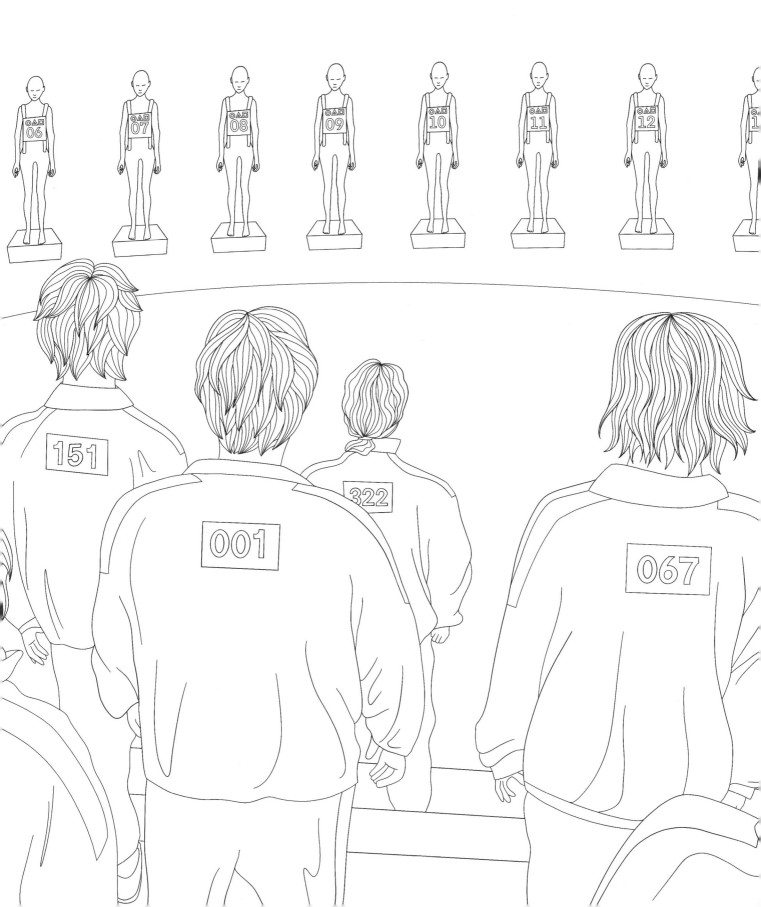

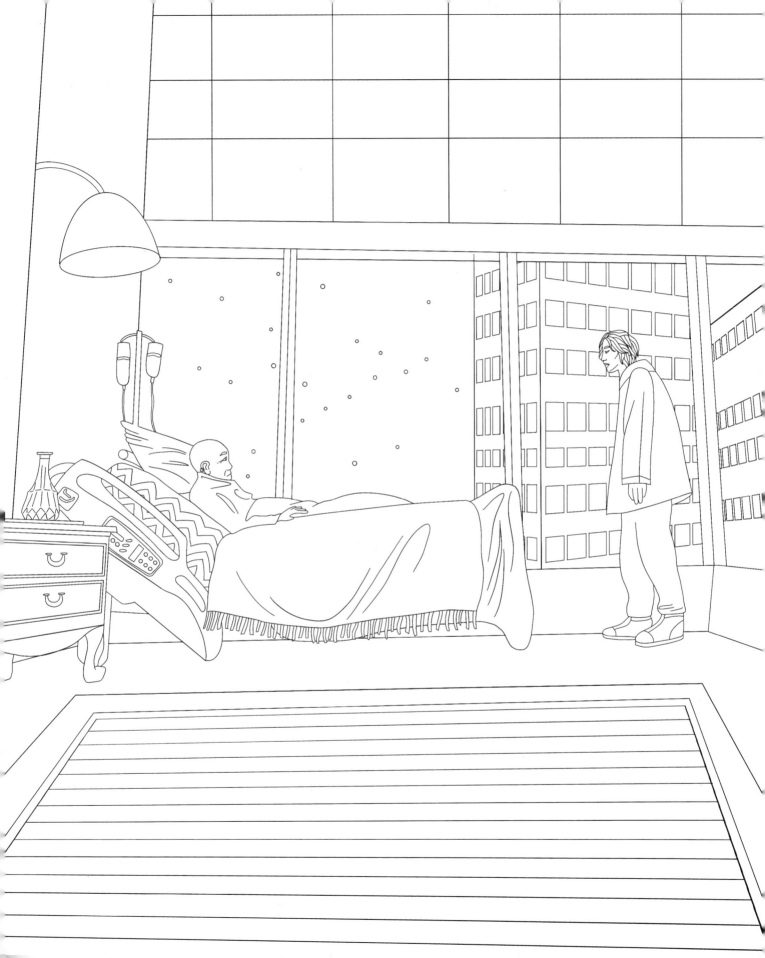

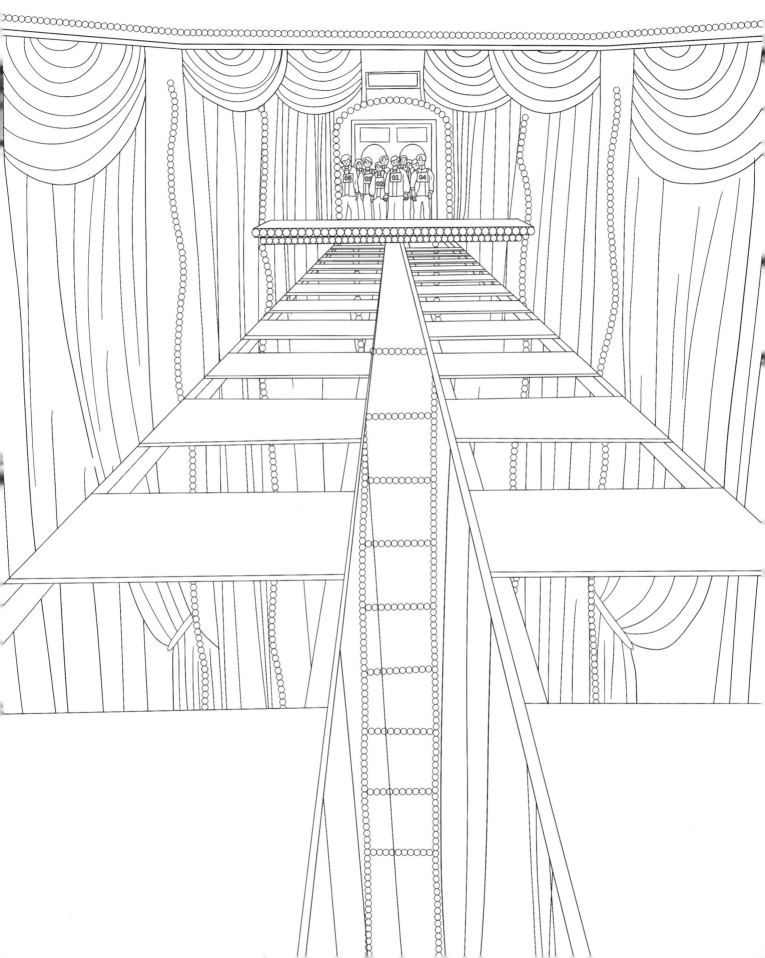

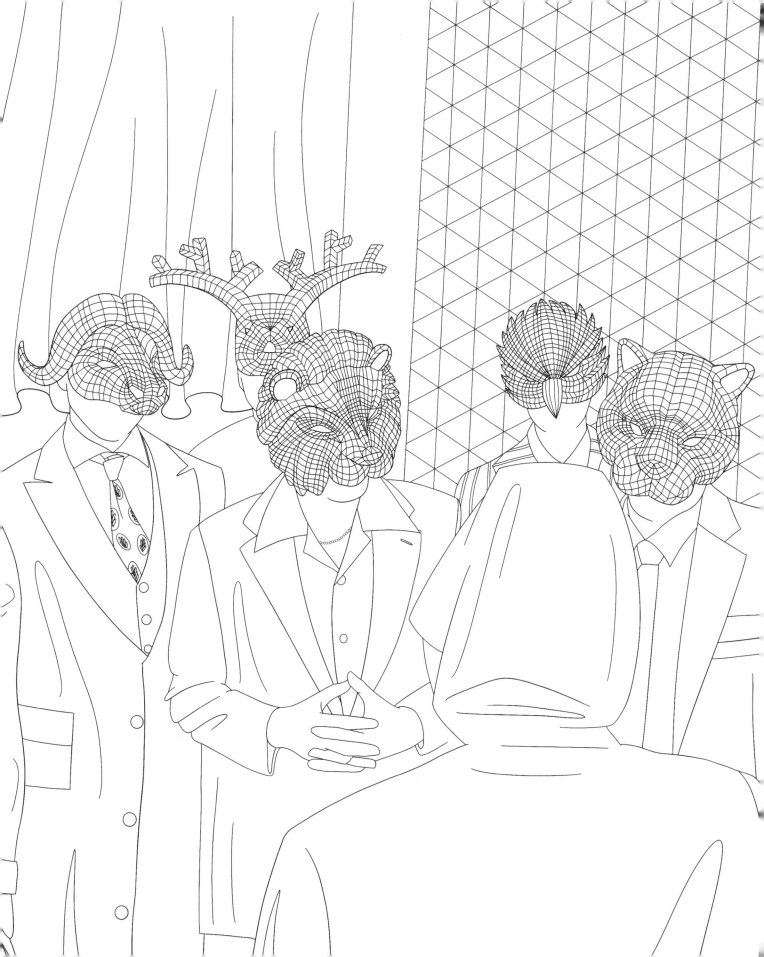

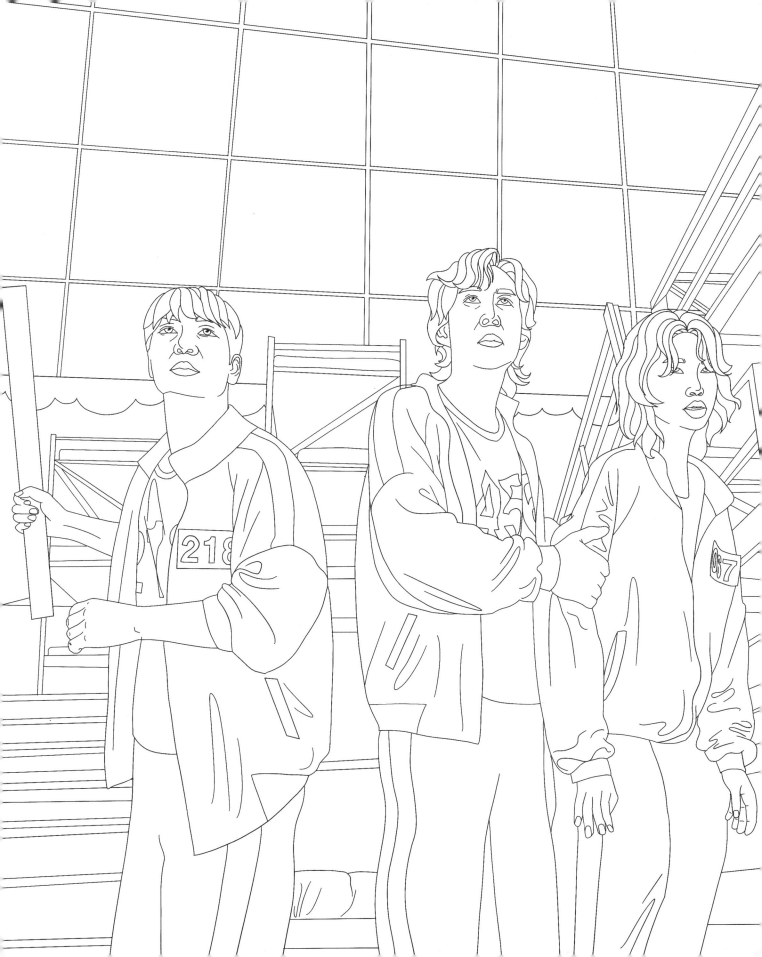

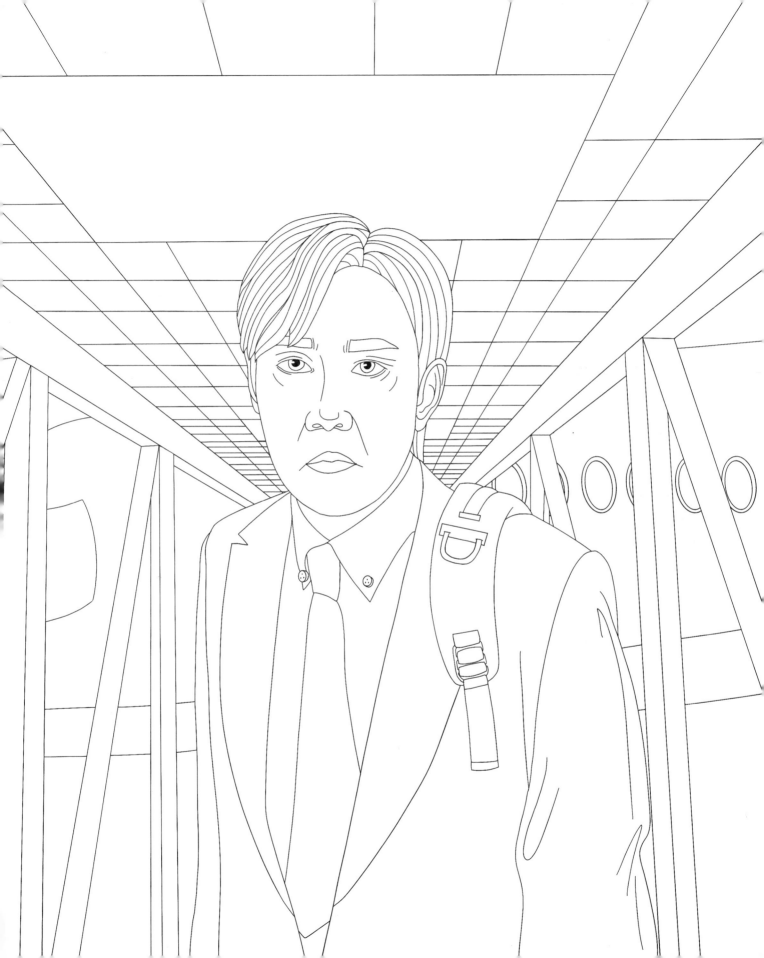

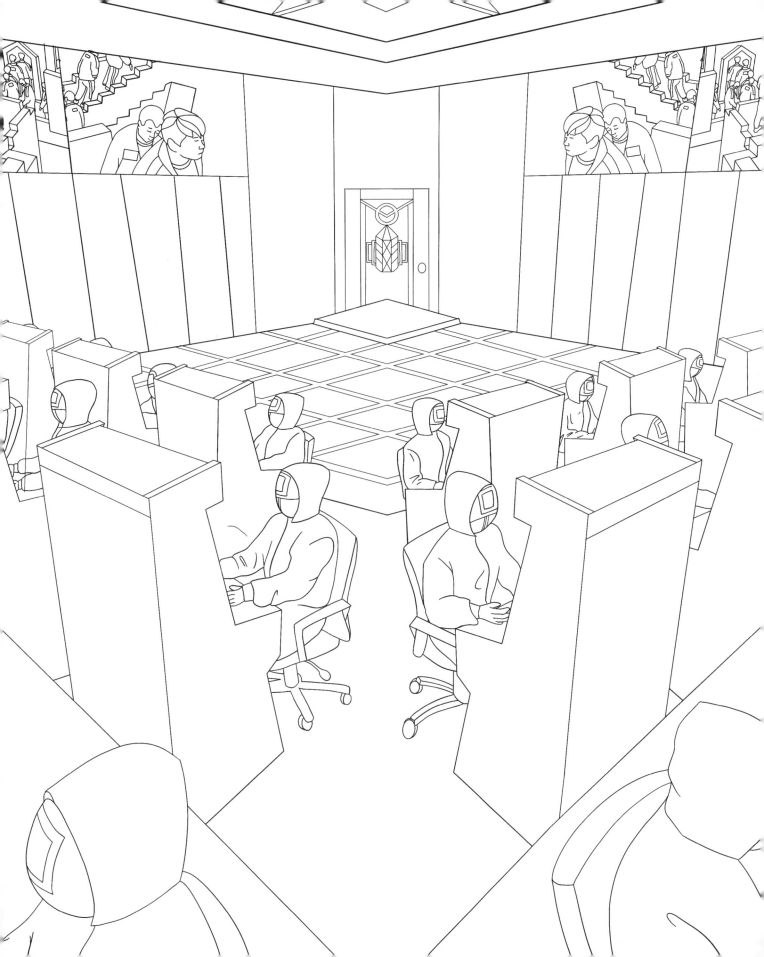

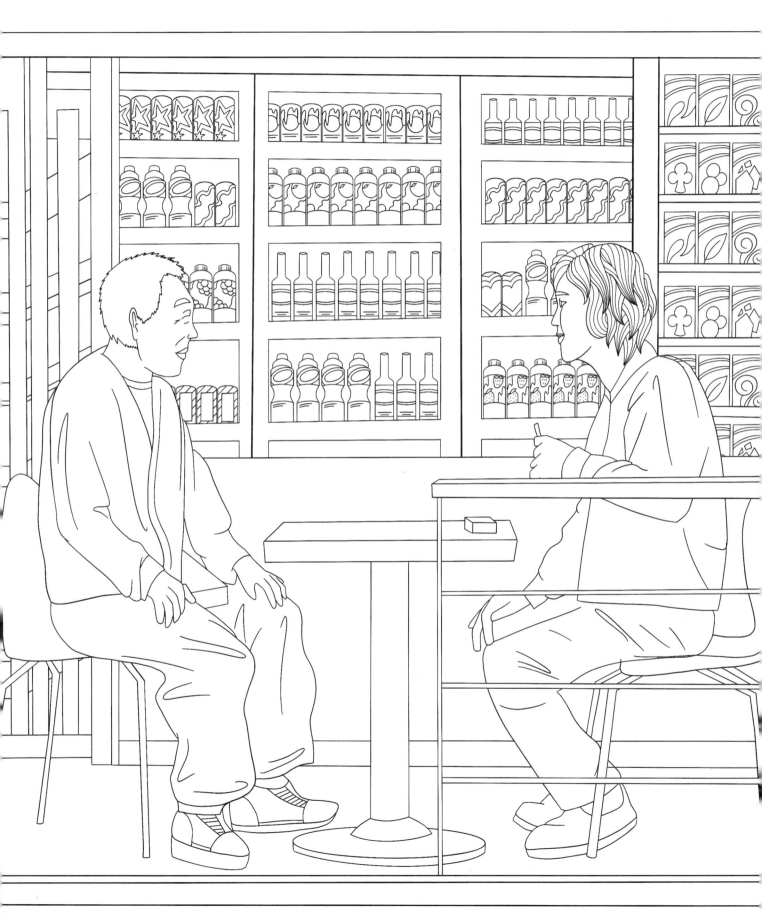

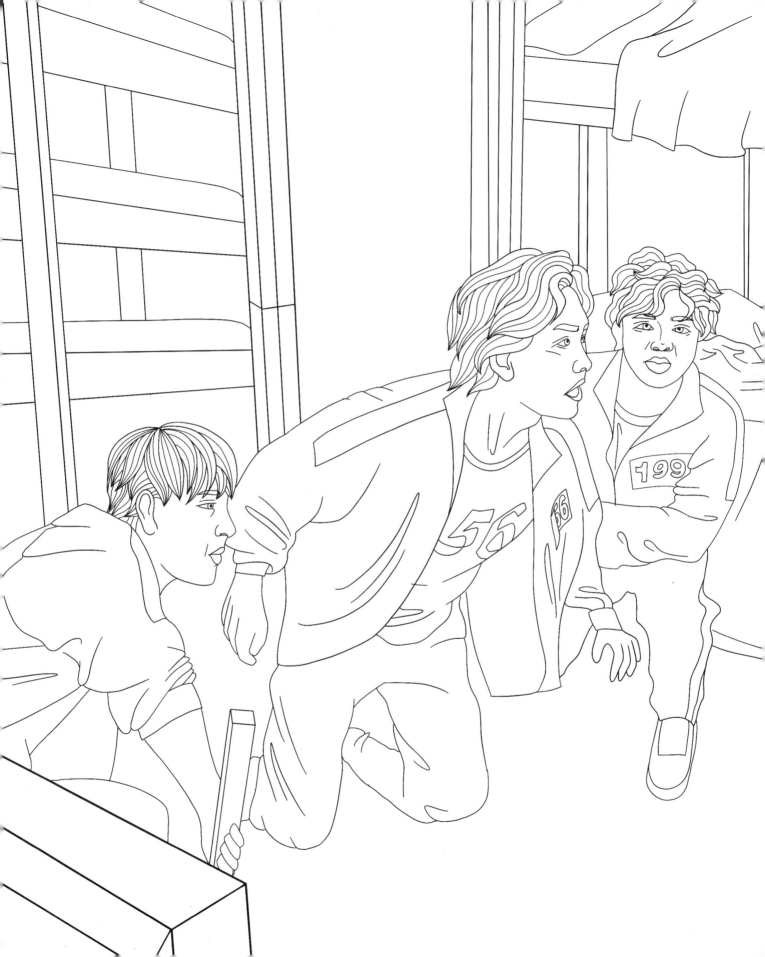

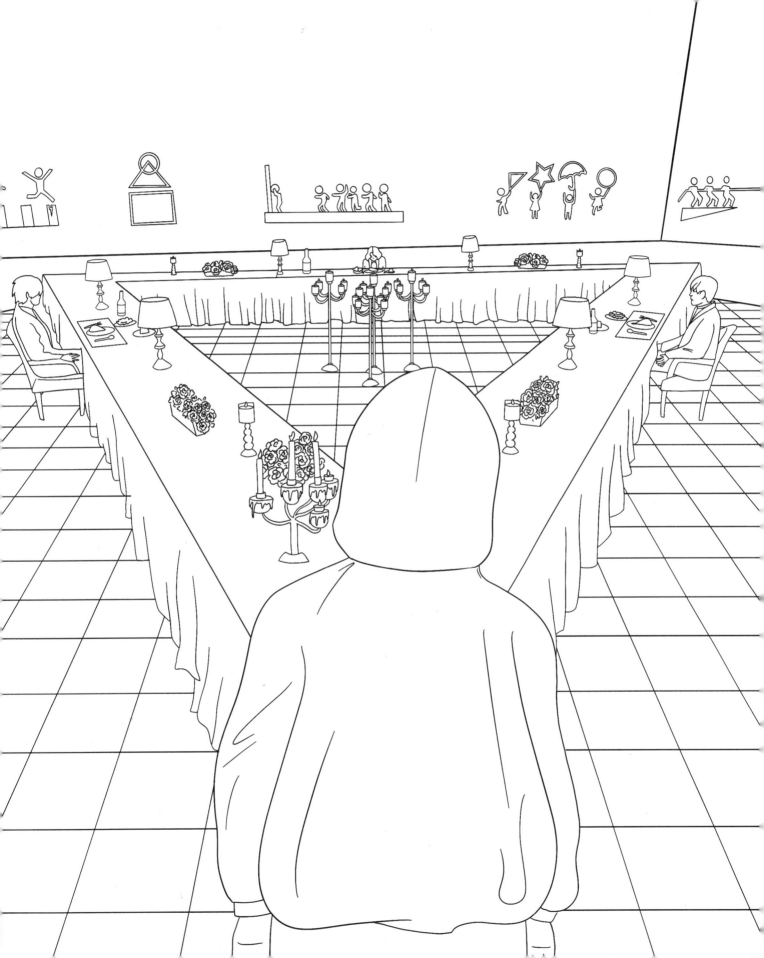

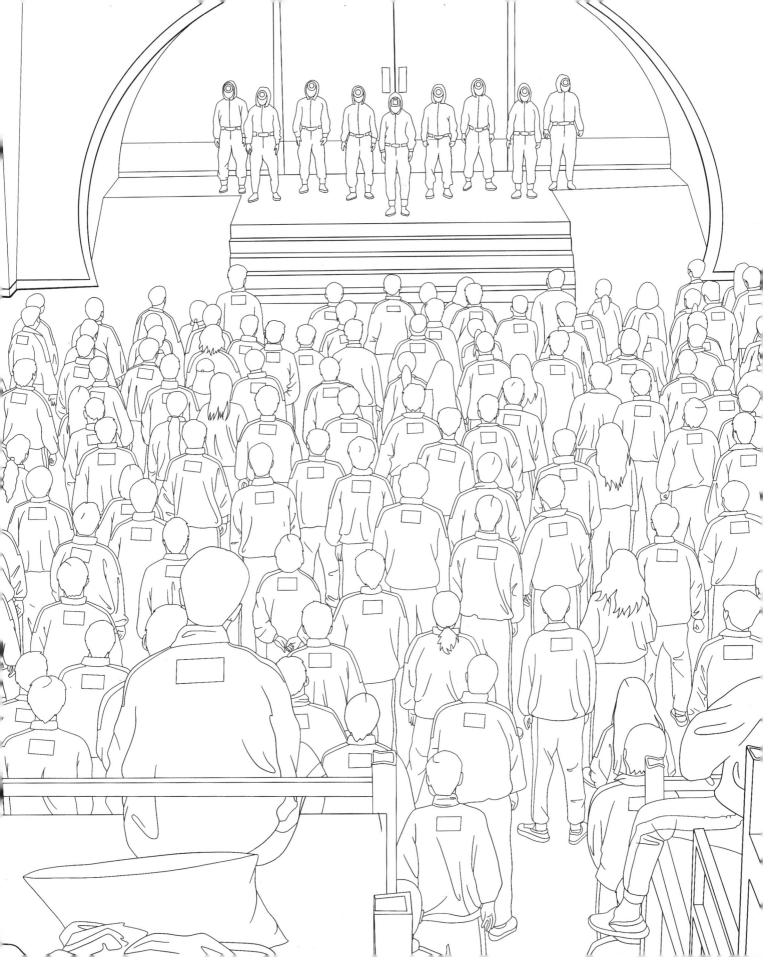

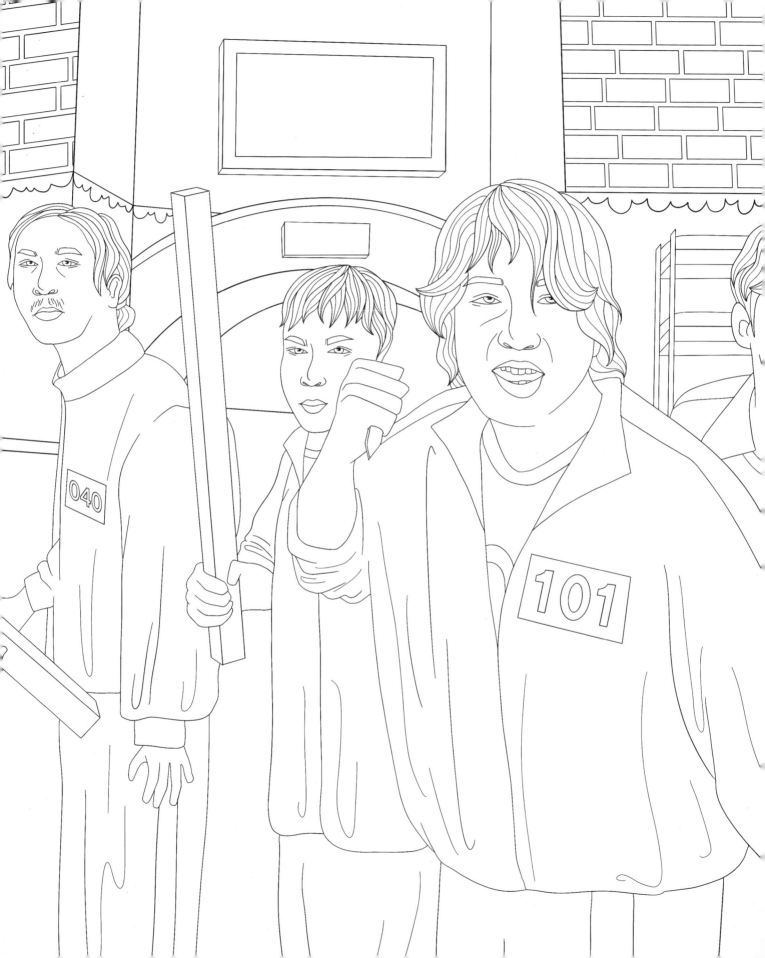

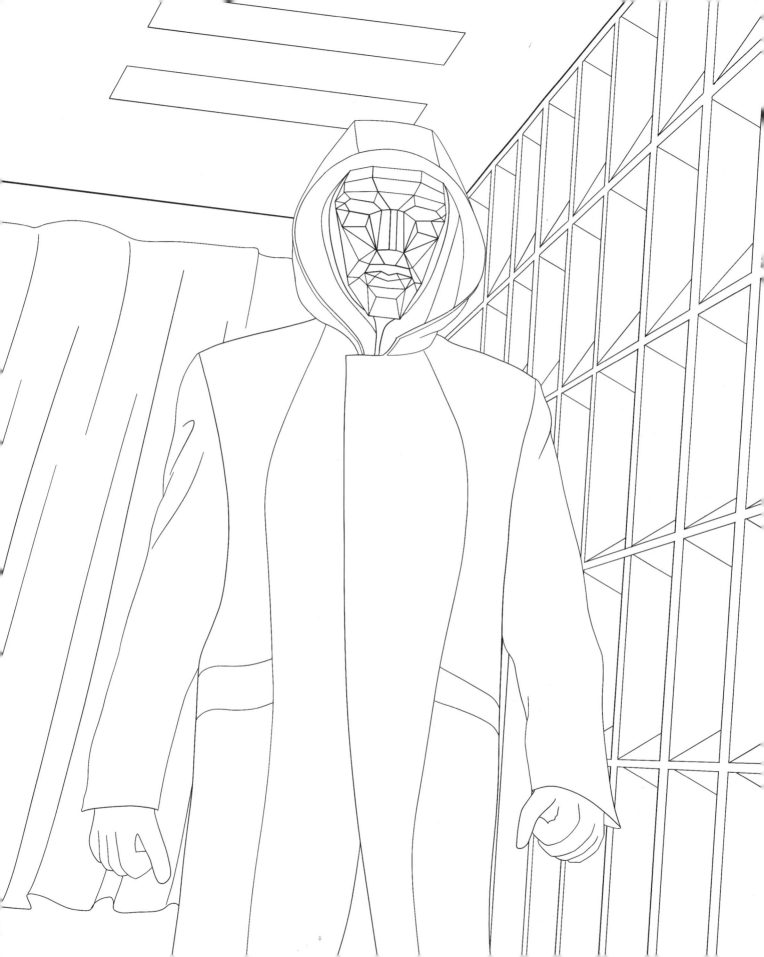

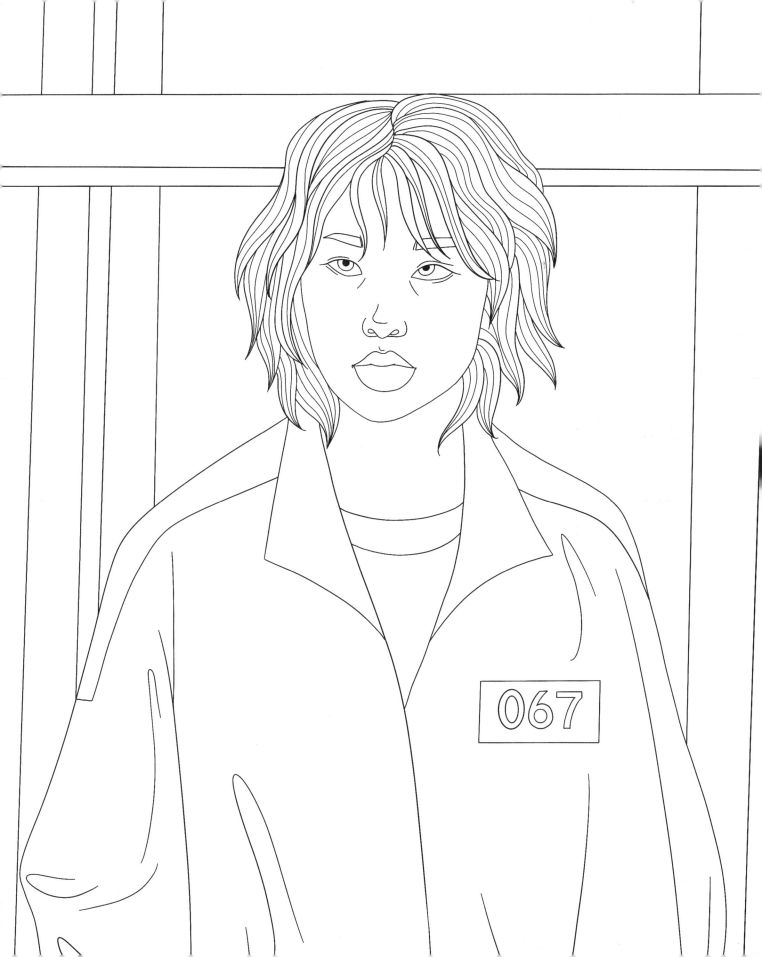

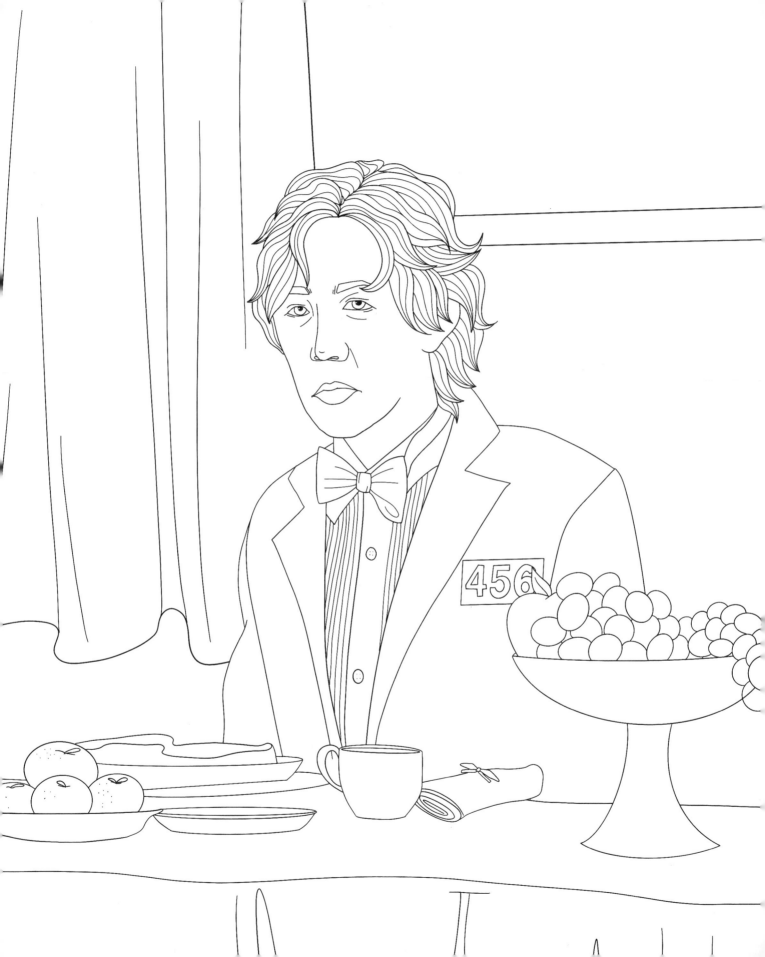

Brimming with creative inspiration, how-to projects, and useful information to enrich your everyday life, quarto.com is a favorite destination for those pursuing their interests and passions.

First published in 2022 by Epic Ink,
an imprint of The Quarto Group,
11120 NE 33rd Place, Suite 201,
Bellevue, WA 98004 USA
T (425) 827-7120 F (425) 828-9659
www.Quarto.com

10 9 8 7 6 5 4 3 2 1

Epic Ink titles are also available at discount for retail, wholesale, promotional, and bulk purchase. For details, contact the Special Sales Manager by email at specialsales@quarto.com or by mail at The Quarto Group, Attn: Special Sales Manager, 100 Cummings Center Suite 265D, Beverly, MA 01915, USA.

ISBN: 978-0-7603-7753-6

Printed in USA